DOUBLE LIVES

American Painters as Illustrators, 1850–1950

New Britain Museum of American Art
NEW BRITAIN, CONNECTICUT

Distributed by University Press of New England
HANOVER AND LONDON

Copyright © 2008 New Britain Museum of American Art,
56 Lexington Street, New Britain, Connecticut 06052-1414.
Telephone (860) 229-0257; Fax (860) 229-3445
www.nbmaa.org
September 7 – November 23, 2008 Brandywine River Museum
December 10, 2008 – February 22, 2009 New Britain Museum of American Art

Distributed by University Press of New England
One Court Street
Lebanon, New Hampshire 03766
www.upne.com

Library of Congress Control Number: 2008937185
Printed in the United States of America
ISBN-10: 0-9724497-7-9
ISBN-13: 978-0-9724497-7-9

Photography by: James Kopp, New Britain Museum of American Art
Edited by: Pamela Barr, New York
Designed and Printed by: Capital Offset Co., Inc., New Hampshire

Front Cover: Childe Hassam (1859–1935), *Le Jour du Grand Prix* (DETAIL), see page 34
First Frontispiece: Frederick Frieseke (1874–1939), *The Bird Cage* (DETAIL), see page 53
Second Frontispiece: Edwin Austin Abbey (1852–1911), *Organist at the Gloucester Cathedral* (DETAIL), see page 50
Third Frontispiece: Fidelia Bridges (1834–1923), *Bird in Thicket* (DETAIL), see page 51
Back Cover: Childe Hassam (1859–1935), *"So they all sat down some on big stones and the others on the grass"*

Contents

5 Introduction

9 Acknowledgments

11 **DOUBLE LIVES**
American Painters as Illustrators, 1850–1950
RICHARD J. BOYLE

49 Color Plates

71 Checklist

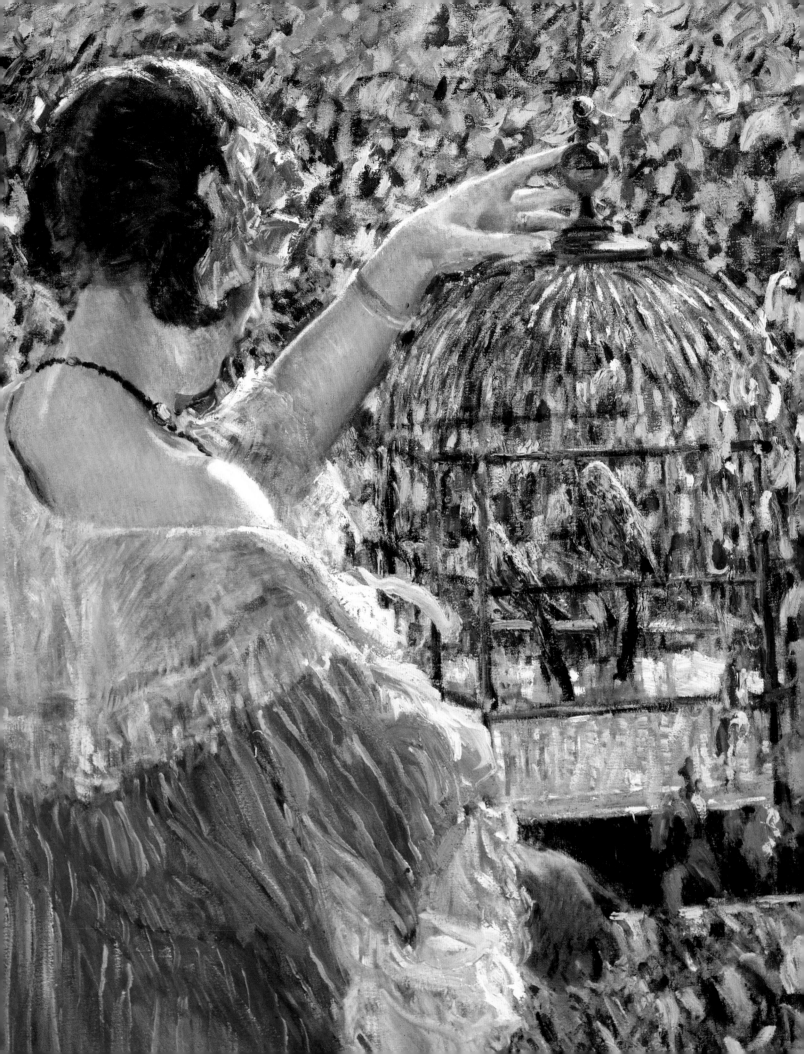

Introduction

On a recent visit to the New Britain Museum of American Art, Andrew Wyeth II, a grandson of the famous illustrator, explained that an artist friend had once told N. C. Wyeth, "Your pictures are too much painting to be illustrations and too much illustration to be paintings." In very few words, the critic had summarized the dilemma that bedeviled N. C. Wyeth and so many other well-established illustrators who aspired to transcend their commercial endeavors and become members of the fine-art establishment. Wyeth's life's ambition was to take his place among the ranks of such notable American artists as Winslow Homer and Robert Henri, both of whom had also enjoyed careers as illustrators. Unfortunately, he never fully succeeded.

Before joining the staff, the Museum's first director, Sanford B. D. Low, was himself an illustrator as well as a painter of murals, portraits, still lifes, and landscapes. He understood the struggles between these two spheres that gnawed at the minds of his friends and contemporaries. When he was appointed director, he cast a benevolent eye on the popular illustrations of Norman Rockwell, Stevan Dohanos, and dozens of other artists, many of whom lived in Westport, CT, and elsewhere on the East Coast, within easy reach of New York City, where they frequently visited the artistic directors of the *Saturday Evening Post* as well as publishing houses and advertising agencies. Thus it was inevitable that his many illustrator friends offered to donate their paintings in his memory after his sudden and premature death in 1964. The Museum's trustees accepted their gifts, forming the Low Illustration Collection.

Since the beginning, however, these acquisitions have been segregated from the more than 5,000 objects in the fine-art collection. A notable exception was the 1953 purchase of N. C. Wyeth's *Treasure Island* masterpiece *One More Step, Mr. Hands,* which, perhaps due to its iconic stature, became part of the regular collection. In this way, New Britain became one of the first art museums in the United States to rec-

FREDERICK FRIESEKE (1874–1939)
The Bird Cage, c. 1910 (DETAIL)
See page 53

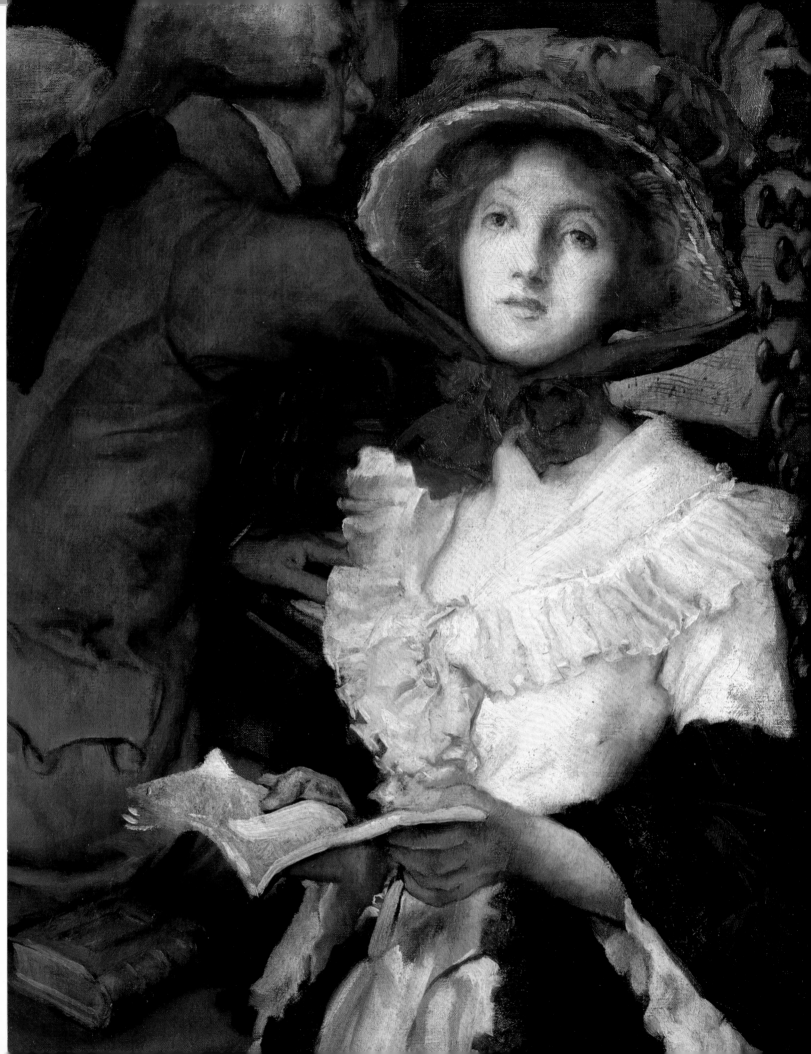

Acknowledgments

In addition to the lenders, who deserve very special thanks, the following people were of tremendous help in organizing this exhibition and its catalogue: Douglas Hyland, Director, New Britain Museum of American Art, and his staff; James Duff, Director, Brandywine River Museum, and his staff; and the members of the Low Illustration Committee, New Britain Museum of American Art, Lindsley Wellman, Chairman. Special thanks also to Walt Reed, who came up with the idea for the exhibition; Martha Hoppin; and Murray Tinkelman. I am grateful to Abigail Runyan, whose help was absolutely indispensable; Jacquelyn Canevari, her intern; and Paula Bender. A special thanks goes to Audrey Lewis, Associate Curator, Brandywine River Museum, for the incredible amount of work she put into this exhibition. Many thanks also to Robert Harmon, Cheryl Leibold, and Gale Rawson of the Pennsylvania Academy of the Fine Arts; Terrence Brown, former Director, Society of Illustrators; Claudine Scoville, Registrar, Peabody Essex Museum; Margaret Stenz and Marguerite Vigilante, The Brooklyn Museum; Christine B. Podmaniczky, Brandywine River Museum; John Callison, Kansas City; Sarah Getz, Sharon, Conn.; Dan Dwyer, JohnnyCake Books, Salisbury, Conn.; Donald Holden; Sharon Wasserman, Director, Library and Research Center, National Museum of Women in the Arts, Washington, D.C.; Bruce Weber, Jeffrey Brown, Henry Adams, and Jerry Wunderlich; Vivian Bullaudy and Debra Pesci, Hollis Taggart Gallery, New York; Professor Jacqueline Francis, University of Michigan; Professor Annette Stott, University of Denver; Professor Eric Segal, University of Florida; Ms. Anne Cannon Palumbo; Kathleen Burnside, Hirschl & Adler Galleries, New York; and Mr. and Mrs. Robin Cecil-Wright, Chinon, France.

Finally, a special acknowledgment, not to a person, but to a collection: the paintings and illustrations from the collection of the New Britain Museum of American Art included here were both the inspiration and the basis for this exhibition.

EDWIN AUSTIN ABBEY (1852–1911)
Organist at the Gloucester Cathedral, c. 1901 (DETAIL)
See page 50

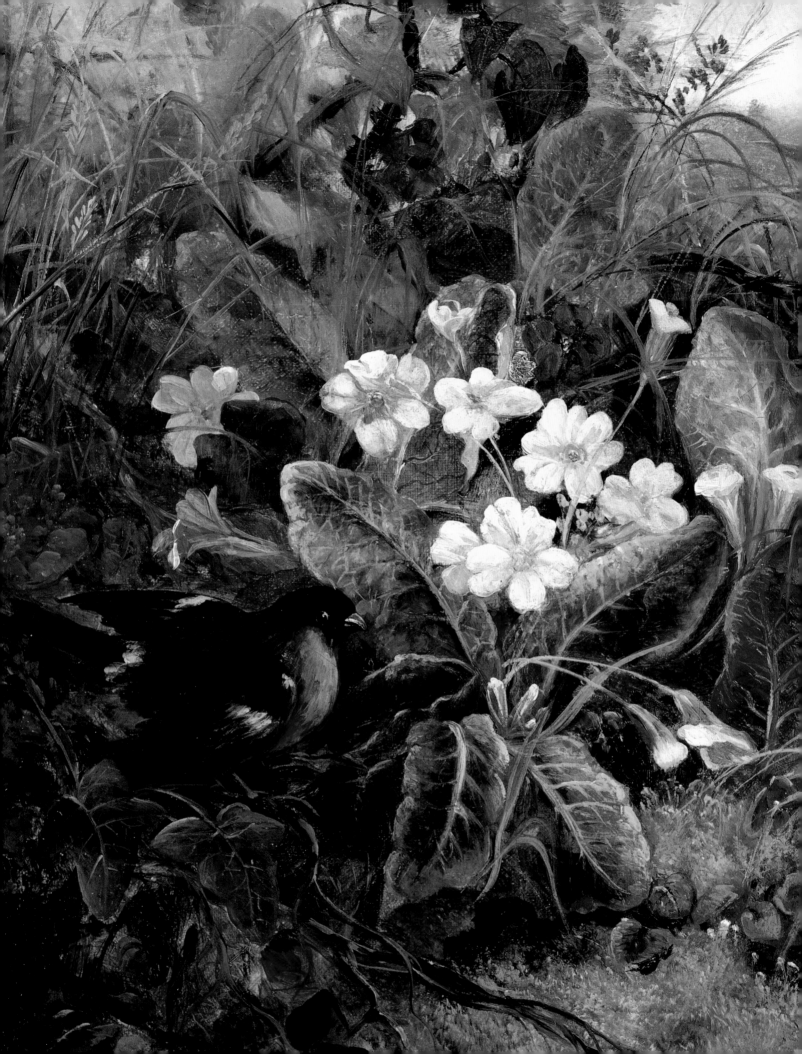

DOUBLE LIVES
American Painters as Illustrators, 1850–1950

RICHARD J. BOYLE

"There were books with frontispieces—the word alone was intoxicating. There were books whose illustrations—by Howard Pyle, N. C. Wyeth, Arthur Rackham, Jesse Wilcox Smith—so imprinted on me that I can still see Blind Pew walking down the hill from the Admiral Benbow.... Each illustration had its own separate page, its own thick glossy paper, smooth and cool to the fingertip. Sometimes the illustrations lay under a translucent leaf of onion skin that, when drawn aside, made a slight crumbly sound and revealed its delicately engraved scene as a fog lifts to reveal the details of a shoreline."

"In the history of art, an artist who is an illustrator wears a 'Scarlet I.'"

These quotes represent opposing views of the art of illustration.[1] The tension that arises from these views is a driving theme of this exhibition. The hows and whys of this notion are explored through the eyes of artists who were actively engaged in both the art of independent easel painting and the art of illustration between 1850 and 1950. For the most part, the practice of illustration was treated if not with disdain then certainly with ambivalence on the part of painters of the fine arts and art historians alike and, to a certain extent, still is.[2] Nevertheless, the deceptively simple two-part question that art historians must ask—how does a work of art come into existence and why does it look the way it does?—is certainly relevant to the art of illustration. Further, it is a discipline that has attracted many of the most talented and innovative American artists, who have created some of the most memorable images in the medium. In some ways illustration is not unlike the art of portraiture. Be it the paintings of John Singer

FIDELIA BRIDGES (1834–1923)
Bird in Thicket, n.d. (DETAIL)
See page 51

Sargent and William Merritt Chase or of Ellen Emmet Rand, the portraitist's primary task is to come up with a likeness of the sitter; that being understood, the making of a work of art is then up to the talents and skills of the artist. The relationship between image and text goes directly to the heart of the principal difference between illustration and the fine arts. "There is a difference," wrote Estelle Jussim, "between the codifying of a visual idea by the . . . fine artist whose purpose is to create an object not necessarily destined to be an illustration in a book or periodical, and the illustrator, whose purpose is primarily to create an object suitable for reproduction. Nothing prevents an individual from performing both these functions."[3] Of interest here are those artists "performing both these functions."

Between 1850 and 1950 a number of American artists turned to illustration for a variety of different reasons. For some it was an initial career choice, a desirable profession, as in the case of Frederick Frieseke; for others, such as John LaFarge or Elihu Vedder, it was another form of creative expression, an extension of the work they already did; for Henry Farny, Frederic Remington, and Edwin Austin Abbey there was no difference between their independent easel painting and their work for publication; and for still others, such as Ellen Emmet Rand and Willard Metcalf, it was a way to earn a living or augment an income.

The many forms of illustration—literary, scientific, technological, and journalistic—have a long history, which, like the art of filmmaking, is intertwined with the fine arts, literature (or certainly the printed word), technology, and business. "Book illumination," wrote Kurt Weitzmann, "was invented to facilitate the comprehension of a written document by the addition of diagrams for scientific treatises, and of illustrated scenes for literary texts. . . . Illustration is also used to complement the text in works of fiction, where it is used to emphasize certain paragraphs and to add helpful pictures for the non-scholarly reader." Further, at a time "when knowledge was being spread mechanically by books, and anonymously by the publishing business, illustration," according to Michael Melot, "overleaped the language barrier. . . . It spoke the language of . . . direct observation."[4]

Obviously the business of illustration is the publishing business; illustration's relationship to literature and the written word can be complicated and sometimes ambiguous, but simply put it consists of a role that is simultaneously dependent and creative, one that both describes and enhances the text. The creation of an image that performs these functions depends, of course, on the mind and hand of the artist. And the artist, like the publisher, must depend on the latest in print technol-

ogy in order to realize his or her intentions successfully. Both the fine arts and illustration are very much affected by advances in technology; while technology has played an important role in the history of the fine arts, the history of illustration is virtually inseparable from the history of technology—specifically that of publication and image reproduction.

The invention of new pigments changed the character of independent easel painting in the nineteenth century. The invention of the collapsible tin tube in 1841 by the American painter John Rand enabled artists to work outdoors, spawning Impressionism. There were only two pigments on Monet's palette that existed before the nineteenth century: lead white and vermilion. It is hard to imagine Vincent van Gogh or Henri Matisse without the new colors, or, indeed, such American artists as LaFarge, Winslow Homer, Henry McCarter, and, of course, the American Impressionists Frieseke, Childe Hassam, Metcalf, and Remington. (The independent easel painting of N. C. Wyeth was also affected, but his illustrations in color would have to wait for the appropriate advances in print technology.) But it was the invention of photography by Louis-Jacques-Mandé Daguerre in France and Henry Fox Talbot in England and its public introduction in 1839 that exerted a major influence on the visual arts and their public dissemination, changing not only how images could be made but also how they could be printed. It provided Édouard Manet and the Americans Everett Shinn and Remington with not only a new technique but also a new concept of space, time, and movement. In his elimination of the half, or middle, tone in painting, Manet was inspired by the awkward early technology of the daguerreotype, which gave his work a sense of immediacy. Shinn, like Edgar Degas before him, made compositional use of the camera's snapshot effect, its apparent continuity of space, and its feeling of a moment in time; Remington was much influenced by Eadweard Muybridge's studies of animals in motion. Photoengraving and photolithography made printing easier and cheaper, changing the course of the publishing industry and hence the course of illustration. The invention of the camera also laid the groundwork for the invention of the motion picture, which would become a new form of illustration, particularly in the filming of books and plays.

Generally, the development of illustration paralleled that of the printed word. Woodcuts were first used to illustrate books; as they were created in a similar fashion as printed text—the ink was applied to the raised areas of the carved block—and the two could be combined on the same page. The woodcut was replaced by engraving and etching, techniques in which the ink settles into lines cut into the

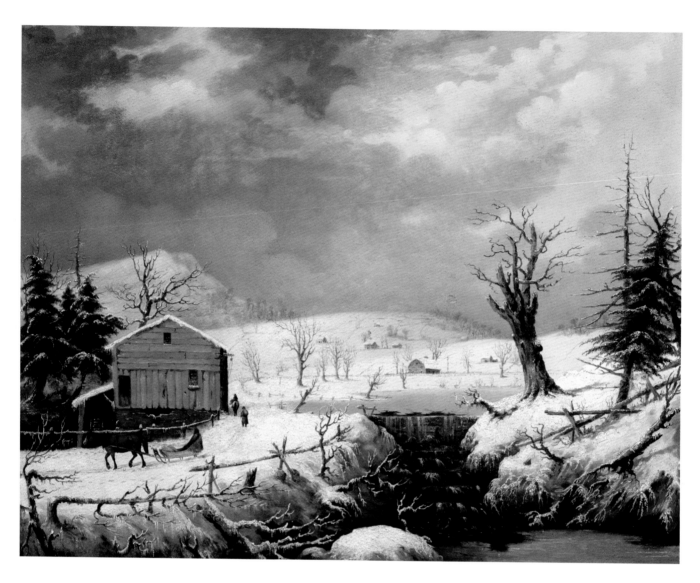

fig. 1

GEORGE DURRIE (1820–1863)
Winter in New England, 1851
Oil on panel
19⅞ x 25 inches
New Britain Museum of American Art
Stephen B. Lawrence Fund, 1958.11

surface, making it difficult, if not impossible, to combine them on the same page. Lithography, which was invented in the late eighteenth century, is a planar, or surface process in which the image is drawn using a lithographic crayon. When colors are added, they settle where the wax has not been applied. While this technique gave the artist a great deal of freedom and control, it also meant that under certain circumstances, such as book and magazine illustration, the illustration was also isolated from the text—"out in the margin," so to speak. An example of an out-in-the-margin illustration is the engraving of the oil painting *The Young Merchants* of 1842 by William Page that was used to illustrate a story by Seba Smith published in *The Gift, a Christmas and New Year's Present for 1844.*[5] The revival of the woodcut through the new technique of wood-block engraving, which appeared in

England and France about 1817 and in the United States somewhat later, reunited image and text once again. In the late 1840s chromolithography made its appearance. Two decades later the development of color lithography by the Frenchman Jules Cheret led to the art-poster movement. The posters by Gerrit Benecker and Ben Shahn, for example, are closer to the art poster than to chromolithographs.

Chromolithography initially was used for advertisements and for the reproduction of paintings and is reflected in the rapid rise and popularity of such printing firms as L. Prang and Company in Boston, Tuschfarber in Cincinnati, and the famous Currier and Ives in New York. George Durrie's popular New England scenes, such as *Winter in New England* of 1851 (fig. 1), became more popular still when Currier and Ives made them into mass-market chromolithographs—for instance, *Winter in the Country: A Cold Morning* of 1867. Most of the firm's designs were done in black and white and colored by hand—at least in the early days. Of the specialist printers in chromolithography, none was more successful than Louis Prang. A German printer who had immigrated to Boston and founded L. Prang and Company in 1856, he published tremendous numbers of prints as well as magazines, trade cards, greeting cards, calendars and, eventually, art-school texts and materials. By the 1880s the firm employed well over one hundred designers and illustrators, many of them women, such as the Connecticut artist Fidelia Bridges, who did a number of watercolors for reproduction by Prang.[6]

In the 1880s the half-tone process was invented, which ultimately would lead to better and cheaper color reproductions; photoengraving replaced wood engraving, and photolithography replaced lithography for general printing purposes. Perhaps the most famous artist in the United States during the period, Maxfield Parrish, was highly cognizant of technology and technique—in fact, he was the master of "special effects." His somewhat ethereal landscapes such as *Dusk* of 1942 (fig. 2, pg. 16), highly decorative designs, sumptuous color, and attention to detail made him one of the most sought after painter-illustrators of his time. He combined Old Master methods with the latest photographic technology, which gave his work its fairy-tale quality. For example, he used the ancient technique of glazing with transparent colors, but his method of using layers of transparent glazing had less to do with the Old Masters than with matching a modern color printing process. He was the perfect artist to illustrate Edith Wharton's classic, *Italian Villas and Their Gardens* of 1904.

Thus the origins of graphic design, of which illustration is an important part, lie very much in the tremendous revolution in print technology, which includes rotary and high-speed presses. In addition, developments in transportation and "the significance of such related cultural changes as the mass production and marketing of publications, increased literacy and urbanization, all helped produce the enormous growth of printed matter," much of which was illustrated.[7]

Because they were publishing centers, the largest American cities (New York, Philadelphia, Boston, Chicago, and Cincinnati) provided artists with opportunities to augment their incomes, or actually have an income, by illustrating books and periodicals, engraving banknotes, and designing lithographic and other advertisements. Illustrators became "stars," and the magazines competed for the most popular of them. "In 1905, Collier's announced that henceforth seven artists would work 'exclusively for Collier's.' Included in this seven were Charles Dana Gibson, Parrish, and Remington."[8] The phenomenon was similar to what would later become the Hollywood star system.

Illustration made great headway in journalism, where the visual element became almost immediately popular and was an important part of newspaper reporting before the widespread use of photography.

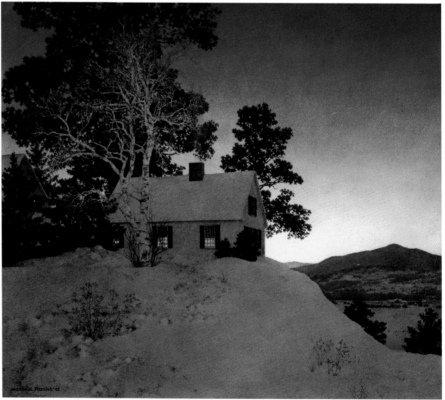

fig. 2

MAXFIELD PARRISH (1870–1966)
Dusk, 1942
Oil on masonite
13⅜ x 15⅝ inches
New Britain Museum of American Art
Charles F. Smith Fund, 1966.52

In England, France, Germany, and the United States there appeared numerous illustrated news magazines such as *Le Magasin Pittoresque, L'Illustration, Der Illustrierte Zeitung*, and *Punch*. The remarkable lithographs of Honoré Daumier, replete with social and political commentary, set a high standard, and his work was enormously influential well into the twentieth century—for instance, on Sloan's work for *The Masses*. By the end of the eighteenth century, advertisements in American newspapers were at times accompanied by small illustrations, or "cuts." By 1840 their use had become more common, and by 1870 they had become widespread. Although the term was not used until the 1920s, Alexander Anderson (1775–1870) is usually acknowledged as the first American "graphic designer" and certainly the first American wood engraver; it is ironic that he died at roughly the beginning of the "golden age" of illustration.[9]

With the publication of the lithograph *The Awful Conflagration of the Steamboat "Lexington,"* in Long Island Sound, Nathaniel Currier's reputation was established almost overnight. On January 13, 1840,

fig. 3

WINSLOW HOMER (1836–1910)
News From the War, 1862
Wood engraving
Illustration for *Harper's Weekly*, June 14, 1862
20¼ x 13¼ inches
New Britain Museum of American Art
William F. Brooks Fund, 1977.01.21 LIC

the steamboat *Lexington* caught fire in the Long Island Sound with forty members of the crew and one hundred passengers on board. In an "extra" edition of the *New York Sun*, Currier published a picture of the disaster, based on verbal descriptions and drawn by W. K. Hewitt. The demand for picture and story was tremendous; this early instance of illustrated reporting changed the course of journalism.[10] *Frank Leslie's Illustrated Newspaper* and Harper Brothers publications both provided illustrated reports of the American Civil War in which the work of Homer played an important role and prepared him for his future career; by the 1850s Harper and Brothers (founded as J. and J. Harper in 1817) had become the largest printing and publishing company in the world.

By the beginning of the Civil War, Homer had established a reputation as an illustrator and became an artist-correspondent for *Harper's Weekly*, traveling with the Union Army and sending back more than one hundred sketches about, or related to, the war. From this experience Homer produced some of his most memorable early images such as the engraving *The Sharp Shooter on Picket Duty*, which appeared in *Harper's Weekly* on November 15, 1862, and the oil *Prisoners from the Front* of 1866 (Metropolitan Museum of Art, New York). Homer's point of view was that of the individual soldier, and in that he anticipated the dedicated military artists of World War II. For the most part he sent back to the readers of *Harper's Weekly* a description of the daily life in the camps. It was a deceptive domestic view such as that depicted in *News from the War* of 1862 (fig. 3, pg. 17) and not

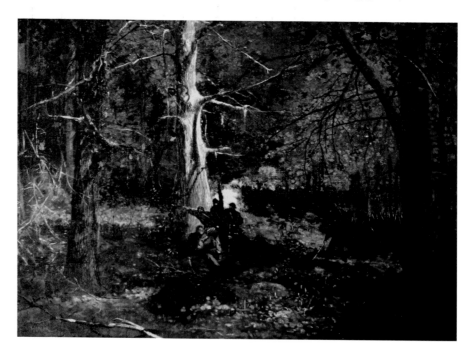

fig. 4

WINSLOW HOMER (1836–1910)
Skirmish in the Wilderness, 1864
Oil on canvas
18 x 26¼ inches
New Britain Museum of American Art
Harriet Russell Stanley Fund, 1944.05

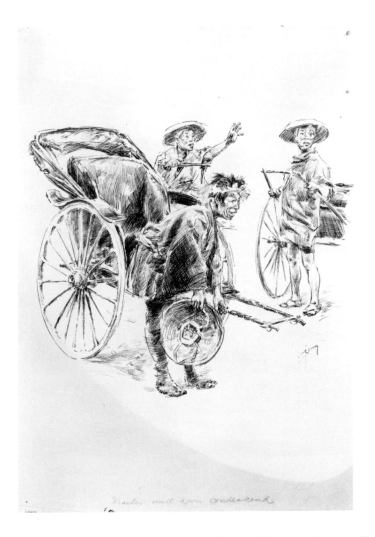

Master will you condescend

fig. 5

ROBERT BLUM (1857–1903)
Master Will You Condescend (Rickshaw Men)
Pen and ink on paper, 13⅞ x 9⅞ inches
Robert Blum. "An Artist in Japan".
Scribners, June 1893.
Brandywine River Museum
The Jane Collette Wilcox Collection, 1982
82.16.17

without its grim side; included in the collage of images in that illustration are scenes of two maimed soldiers and a woman with bowed head holding a letter, presumably from the War Department, informing her of the death of a husband or a brother. Homer's *Skirmish in the Wilderness* of 1864 (fig. 4) is unusual for both his painting and his illustration—with few exceptions, Homer rarely painted soldiers in the heat of battle.

There appeared to be three main events that had a singular impact on Homer's mature work: his intensive training as an illustrator, with its emphasis on observation and insistence on the right dramatic moment; the Civil War; and his visit in the 1880s to Cullercoats, on the coast of England, where he observed the hard life of the fishermen and their families. After that experience his work took on a definite "edge," becoming a profound study of the sea and its effect on the people who make a living from it, all of which led to the late, great paintings.[11]

Although not necessarily an artist-reporter, Robert Frederick Blum wore that hat in two of his best-known works for publication: his illustrations for Sir Edwin Arnold's *Japonica* (1892), a commission that took the artist to Japan; and those for his own article "An Artist in Japan" in *Scribner's* (June 1893) in which the charming pen-and-ink illustration *Master Will You Condescend (Rickshaw Men)* appeared (fig. 5, pg. 19). Like Abbey, Blum first made his reputation as a draftsman but soon became known for his versatility in other media, including oil painting and mural work. The apparent tension between the two figures in his oil *Two Idlers* belies the tranquility of its idyllic setting and its ambiguity expands the traditional notion of narrative painting.

In 1898 William Glackens and Remington became artist-correspondents, reporting on the Spanish-American War. Sloan, in his role as both artist and editor for the politically radical magazine *The Masses*, and Shinn, with his paintings and illustrations of theater subjects, were very much a part of the artist-reporter tradition. Glackens, Shinn, and

Sloan actually were newspaper illustrators before they became painters, and under the influence of their mentor and friend Robert Henri, they applied their illustrator's skills to depicting scenes of fast-paced urban life. Glackens's illustration *Patrick Joseph Went and Bought Himself a Grocery Store on Monroe Street* of 1912 (fig. 6) and his painting of what was then more "uptown" subject *Washington Square* of 1910 (fig. 7) charged those urban subjects with a new kind of reality. A student of Sloan and Kenneth Miller, Reginald Marsh created works such as *Strokey's Bar* of 1940 (fig. 8, pg. 22) that reflect their gritty realism. His painting and illustration earned him the sobriquet the "American Hogarth." In his illustrations of theater and

fig. 7

WILLIAM GLACKENS (1870–1938)
Washington Square Winter, 1910
Oil on canvas
25 x 30 inches
New Britain Museum of American Art
Charles F. Smith Fund, 1944.03

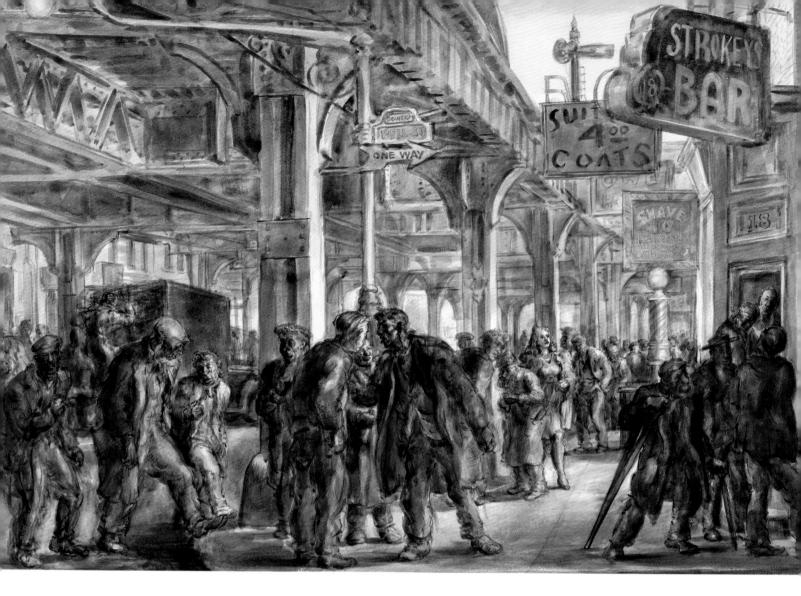

fig. 8

REGINALD MARSH (1898–1954)
Strokey's Bar, 1940
Watercolor
27 x 40 inches
New Britain Museum of American Art
Charles F. Smith Fund, 1941.08

film personalities like Ethel Barrymore, George Abbott, and Walter Pigeon for such newspapers as the *New York Herald Tribune* in the 1930s and 1940s, the Bucks County artist Ben Solowey followed in the path of Everett Shinn. Although Solowey's drawings are incisive and strong, they are different from his paintings, which are more traditional, albeit modern, landscapes, still lifes, and portraits such as the memorable one of his wife, Rae. Arthur Getz considered himself a member of The Eight, and in his paintings as well as his many *New Yorker* covers of New York scenes, he proves to be a descendent of Henri, Glackens, Sloan, and Shinn; his *52nd Street Strip Joint* cover for the *New Yorker* and his *Diner at Night* (fig. 9), both about 1950, capture the spirit of their work beautifully. The full title of Getz's painting is *Diner at Night (A Tribute to Edward Hopper)*, an indication of his considerable admiration for an artist who also began his career as an illustrator and was a student of Henri. While Getz's *New Yorker* cover is appropriately linear for reproduction purposes, his

painting is much more freely handled, but the spirit behind both is similar; the technique may differ, but the enthusiasm for the subject animates both.[12]

As fiction became more popular in Europe and Great Britain in the late eighteenth century, pictures based on the stories slowly began to appear. An illustration began to have a value of its own or added something the text alone could not convey. English periodicals and the novels of Henry Fielding and Samuel Richardson, popular among the new, somewhat sentimental middle class, were served by realistic imagery that added to the delineation of character. In France "the printed book came to be valued additionally for its illustrations and the illustrator's art in the classical age of that country's literature, was the art of choosing the critical moment."[13] Illustration made enormous progress in Europe from the 1830s on, as indicated by the immense output and popularity of such artists as Honoré Daumier, Gustave Doré, and others. According to Phillip Meggs, the three British illustrators Bruce Crane, Randolph Caldecott, and Kate Greenaway "achieved good page design, excellent pictorial composition and a restrained use of color in their work . . . and their influence still lingers." Of the three, Crane is acknowledged as one of the earliest and most influential designers of children's picture books and of illustrated books in general.[14]

fig. 9

ARTHUR GETZ (1913–1996)
Diner at Night (A Tribute to Edward Hopper),
c. 1950
Oil on canvas
28½ x 48 inches
Sarah Getz Collection

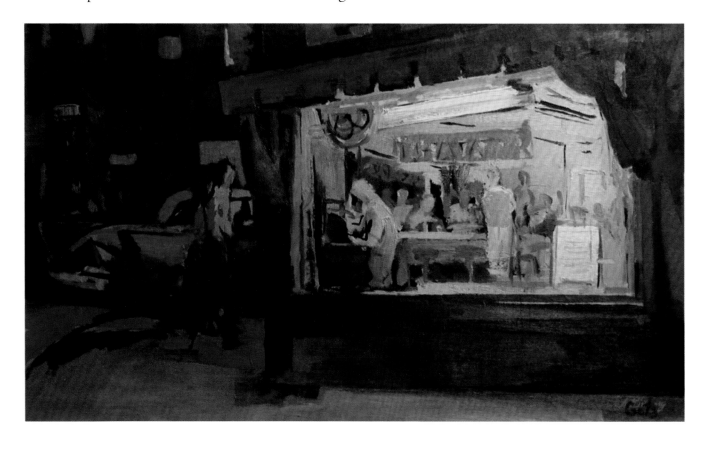

By the last half of the nineteenth century and the beginning of the twentieth, American culture experienced a surge in the rise of visual material available to the public, including books and periodicals, the poster and its outsized offshoot the billboard (indicating the rise of the advertising business), and the beginnings of the comic strip and the film industry. Images were everywhere, and they were produced by at least several thousand trained professional artists, many of whom, like Thomas Moran, Edwin Austin Abbey, Childe Hassam, and Willard Metcalf, began their careers as engravers, lithographers, or illustrators.[15]

Nevertheless, not every writer wanted his work illustrated, and various authors, from the French poet Stephan Mallarmé to Mark Twain and Henry James, were at least wary of it. Mark Twain felt that images needed text for full communication; like the caption in a silent film, no picture could be understood without the accompanying word, and only the written word would do for Mallarmé and James. "Je suis pour—aucun illustration," wrote Mallarmé, whose fear was that visual images "would darken the illuminating power of the text," a sentiment with which James was entirely in agreement. For them, words alone have the ability to evoke images. "A novel with pictures," James wrote, "is like a garden growing two incompatible crops . . . a picture by another hand on my own picture—this being always . . . a lawless incident."[16] It was an instance of text versus image, not image versus image. With the advent and popularity of chromolithography and its ability to reproduce the same image thousands of times, there were cries of "over-illustration" and concerns that images would replace words, all of which led the editor and critic E. L. Godwin to coin the term, "chromo civilization," one in which the reproduction would drive out "authentic" culture.[17] Much of this sentiment was echoed by Walter Benjamin in his celebrated essay of 1932, "The Work of Art in the Age of Mechanical Reproduction," in which he posited that a work of art was unique and impossible to reproduce except in a degraded form. For certain forms of expression, such as photography and the cinema, he insisted on captions as "signposts."[18] Although Benjamin refers primarily to reproductions of original works of art, with what he calls their own "aura," and not to works of art deliberately made for reproduction, the general tenor of his thought seems to be close to that of Mark Twain.[19]

In an assessment of American illustration, one of the important "signposts" is the narrative tradition in American art to which much American illustration properly belongs. Until relatively recently, that

fig. 10

JOHN QUIDOR (1801–1881)
A Knickerbocker Tea Party, 1866
Oil on canvas
27 x 34 inches
New Britain Museum of American Art
Charles F. Smith Fund, 1953.06

tradition, whether in independent easel painting or in illustration, was one of the main streams of American art. However, as Richard Chalfen has pointed out, definitions of narrative have changed or have expanded in recent years. He feels that the definition of narrative as storytelling is perhaps too narrow and that it raises more questions than it answers. What is narrative exactly? Is it "narrative as storytelling? As prescriptive and proscriptive advice? As a tool to attract attention? To aid consumption, or to enforce ideology, among others?"[20] Certainly the influence of modernism has had an effect, expanding traditional narrative from storytelling in a clear continuous line, with a beginning, middle, and end, "to a system that presents ambiguities of interpretation."[21] Yet for the purposes of this project, and even with "ambiguities of interpretation," narrative is defined as storytelling.

The narrative element in American painting from roughly the Colonial era to comparatively recent times has been an important concern of artists of major importance. It can trace its heritage to the history paintings of Benjamin West, such as *Penn's Treaty with the Indians* of 1771–72 (Pennsylvania Academy of the Fine Arts, Philadelphia). There was also early American literature that appealed to such artists as John Quidor, who made his reputation with paintings based upon the writings of Washington Irving, who enjoyed friendships with many New York artists of the day. Numerous artists drew inspiration from Irving's *The Sketch Book of Geoffrey Crayon, Gent* (1819–20).[22] Quidor's *A Knickerbocker Tea Party* of 1866 (fig. 10, pg. 25) derives from the celebrated author's *A History of New-York from the Beginning of the World to the End of the Dutch Dynasty, by Diedrich Knickerbocker* (1809), a lampoon of the Dutch rule in New Amsterdam. While not made specifically for publication, *Knickerbocker Tea Party* is both an illustration and an easel painting, and reflects the point that earlier in the century the distinction between fine art and illustration was a fluid one. In fact, until the turn of the twentieth century and Howard Pyle's school for illustrators in Chadds Ford, Pennsylvania, there seemed to be no clearly defined path to becoming an illustrator and no official training. According to the designer-illustrator Will Bradley, painters "drifted into working for reproduction."[23]

At mid-century, as in Britain earlier, sentimentality began to emerge in narrative, and an idealized genre painting developed along with the growth of the middle class. Aspects of daily life, as depicted in the painting *The Young Merchants*, the paintings of George Durrie, which were mass-produced as lithographs by Currier and Ives, and the illustrations of children by Homer, became popular in the second quarter of the nineteenth century and tended to merge with history painting, changing the latter's form and making it more accessible to the public. By the late nineteenth century history painting reached ordinary Americans who could buy mass-produced publications created by the new printing technology.

After the Civil War, the depiction of American history became fruitful ground for such illustrators as Howard Pyle and his students and Edwin Austin Abbey in both painting and work for publication. Abbey, who made his reputation primarily as a painter-illustrator of English and medieval subjects, was trained as a draftsman in Philadelphia. He developed a delicate yet strong pen-and-ink style, as attested by the illustration *And Strove the Maids to Win (Soldier*

and Peasant Girl) of 1881 (fig. 11) depicting a Cromwellian soldier wooing a country girl in a story that appeared in *Harper's New Monthly* in January 1882. He began to work seriously in oil in 1889; *May Day Morning*, done between 1890 and 1894, was his first major canvas. Like LaFarge, who sometimes used his illustrations as models for oil paintings, Abbey's derived the idea for *May Day Morning* from an illustration, *Corinna's Going a Maying*, made for a book of Robert Herrick's poetry published by Harper's in 1882; recalling the titles for a silent film, a couplet from the poem often accompanied the picture when it was exhibited.[24]

Other forms of narrative such as religious and allegorical painting have never been particularly strong in the United States. There was a brief flirtation with allegory during the mural movement at the end of the nineteenth century, reflected in the work of Vedder; and religious subject matter has come to be associated with Henry O. Tanner and John LaFarge, especially the latter's work in Trinity Church in Boston and the Church of the Ascension in New York, but in the 1860s LaFarge was known for his explorations of color in oil painting and for his innovative illustrations.

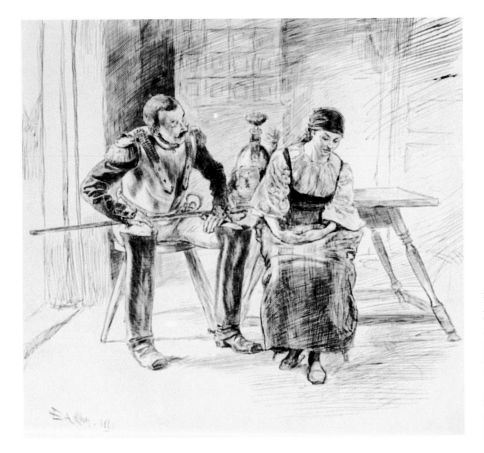

fig. 11

EDWIN AUSTIN ABBEY (1852–1911)
And Strove the Maids to Win (Soldier and Peasant Girl), 1881
Ink on paper
Illustration for Annie Fields, "Pastor Dankwardt," *Harper's New Monthly Magazine*, January 1882
Brandywine River Museum
Gift of Mr. and Mrs. Frank Fowler, 1978
78.22.5

Vedder was a cosmopolitan artist—painter, sculptor, writer, illustrator, designer, and muralist—of varied interests and talents, who became famous for his landscapes and narrative visionary paintings such as *Questions of the Sphinx* of 1863. Just before the Civil War he left Italy and returned to New York, where he earned a living as an illustrator, a discipline for which his imagination and narrative style—influenced by the work of the eighteenth-century British artist William Blake—were perfectly suited. Vedder produced a number of illustrations for such publications as *Frank Leslie's Illustrated Newspaper* and *The Century Magazine*. He did this cover design, perhaps representing knowledge, for *Century* in 1882 just before producing his celebrated design and illustrations for *The Rubáiyát of Omar Khayyám*, written in 1120 by the Persian astronomer and poet and first translated by Edward Fitzgerald in 1859. Vedder's overall style, which may be seen as anticipating Art Nouveau, solidified his reputation as a highly original artist who became a sought-after muralist.[25]

LaFarge, one of the most sophisticated and cosmopolitan American artists of his generation, was born in New York, the son of French émigrés who had escaped the Reign of Terror. In 1859 he studied painting with William Morris Hunt in Newport, Rhode Island, where Henry James was a fellow student. He soon left Hunt's atelier and in the early 1860s painted a series of still lifes and landscapes in and around Newport that were notable for their feeling for color and quality of light, characteristics that would later distinguish his religious paintings. It was no accident that he took to the design of stained-glass windows, even inventing a special opalescent glass. Throughout the 1860s, LaFarge received considerable critical praise for his still-life paintings as well as his book and magazine illustrations.

In 1864, along with Vedder and F. O. C. Darley, LaFarge contributed a series of illustrations for an edition of Alfred, Lord Tennyson's poem *Enoch Arden*, here framed as a single work.[26] Between 1864 and 1868 he completed many commissions for the *Riverside Magazine for Young People*, including *Wise Men Out of the East*, the basis for his later painting *The Halt of the Wise Men* of 1868. The illustrations he made at this time were innovative in style, merging Pre-Raphaelite illustrations reminiscent of those by Edward Burne-Jones and Japanese wood-block prints, of which he was an early admirer, their influence clearly evident in the *Enoch Arden* illustrations. He chose to draw on the block with a Japanese brush rather

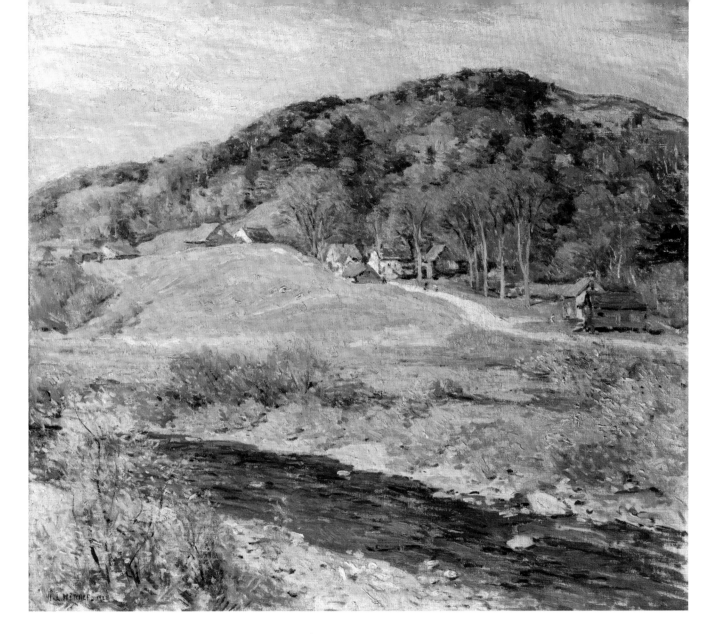

fig. 12

WILLARD METCALF (1858–1925)
November Mosaic, 1922
Oil on canvas
26 x 29 inches
New Britain Museum of American Art
John Butler Talcott Fund, 1925.01

with a pencil or pen, creating a special effect that impressed other artists, including Homer and Moran. Because the technology of wood engraving at that time necessitated the destruction of the artist's original drawing, LaFarge turned to the relatively recent medium of photography to record his images.

The era following the Civil War saw the emergence of the American West, which furnished artists and writers with material that continues to be used to this day. The Western landscapes of Moran, painted for himself as well for publication, and the illustrations of Zuni life in the Southwest by Metcalf of the early 1880s helped raise public consciousness. The easel paintings and illustrations by Henry Farny and Remington provided the public with fact and fiction, virtually creating "the Western." Remington, in particular, had an enormous influence on the film director John Ford.

By the time Metcalf painted *November Mosaic* in 1922 (fig. 12, pg. 29), he had already made his reputation as an artist who rendered the "American," specifically New England, landscape. He worked in a modified Impressionist idiom and a deceptively straightforward manner, celebrating the natural world in the area where he was born and raised, leaving a series of images that resonate today. In the struggle to achieve that reputation, Metcalf turned to illustration to make a living until he could do so through the sales of his paintings. He pursued illustration in order to pay for a chance to study in Paris, a long-held goal, which he did in 1883, remaining in France until 1888.

Between 1881 and 1896 Metcalf worked actively as an illustrator, creating images for fiction and nonfiction alike—from the work of Robert Louis Stevenson to articles by the celebrated actor John Drew—but his most interesting assignment took him to New Mexico to illustrate news stories on the Zuni Indians by Sylvester Baxter, a Boston journalist and writer, and to collaborate with Henry Farny on a series of articles by the ethnologist Frank Hamilton Cushing entitled *My Adventures in Zuni*. Metcalf remained in the Southwest from 1881 to 1883 and became immersed in the Zuni culture. *Zuni Planting Scene* demonstrates Metcalf's direct and straightforward approach to his illustration work, which was somewhat influenced by that of A. B. Frost. Although Metcalf's modified Impressionist style as a landscape painter was quite different from his style as an illustrator, they share the characteristics of directness and simplicity.[27]

In 1881 Henry Farny made his first trip West, which inspired the paintings and illustrations for which he is best known. That trip was in connection with an illustration project on which he collaborated with Metcalf, drawing the illustrations for "My Life in Zuni," a series

fig. 13

HENRY FRANCIS FARNY (1847–1916)
Indian Frontiersmen, Dogsled and Team,
before 1894
Pen and ink on paper
6¼ x 11 inches (unframed)
Brandywine River Museum
Museum Purchase, 2004

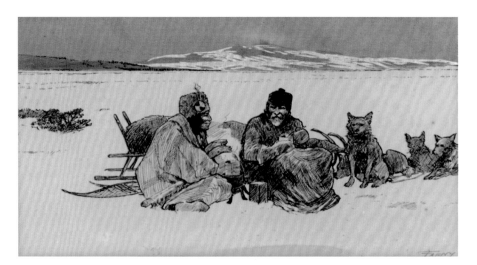

fig. 14

HENRY FRANCIS FARNY (1847–1916)
Last Stand of the Patriarch, 1906
Watercolor and gouache
13¼ x 22½ inches (unframed)
21¼ x 29 inches (framed)
Private Collection

of articles published in Scribner's in 1882 and written by the ethnologist Frank Hamilton Cushing. For Farny, unlike Metcalf, there was little difference between the subject matter in his paintings and illustrations. They were both similarly narrative and descriptive; collectors of fine art as well as editors and art directors bought what he did best—depictions of the Native American. About 1894 Farny made *Indian Frontiersmen, Dogsled and Team,* a pen-and-ink drawing intended for publication (fig. 13). In 1906, at the peak of his fame, he painted *Last Stand of the Patriarch* (fig. 14), a quietly dramatic narrative (and visual metaphor) for the ultimate disappearance of the bison. In general subject and style the illustration and the painting are similar. In both the narrative takes place before a sensitively rendered landscape in the manner of a backdrop in a Western film. All of Farny's paintings and illustrations depict closely observed and sensitively rendered landscapes; were the figures in his paintings removed, they would have been successful landscapes in their own right.[28]

Remington's career embodies the difficulties of a painter-illustrator who had an accessible style and chose subject matter with a broad popular appeal yet was also eager to be accepted as a "serious" artist by an elite cultural establishment. Further, that cultural establishment looked upon the subject of his work, the American West, with fascination tempered by disdain. It was the stuff of government surveys and anthropological studies and also of popular dime-store novels and the tabloid press—of myth rather than fact. Like Metcalf and Farny, Remington made his first trip West in 1881 and visited many times during the following two decades.

In addition to his Western subjects Remington also became known for his portrayal of the military, in which he had a great interest. *The Canadian Mounted Police on a "Musical Ride"—"Charge!"* of 1887 reflects that interest. His drawings reveal his realism, grasp of detail, and flair for action, probably influenced by such French artists as Jean-Louis-Ernest Meissioner and Édouard Detaille. Remington was well within the tradition of military artists and also anticipated films about the military in the West such as *She Wore a Yellow Ribbon* (1949) directed by John Ford. A strong characteristic of his work in all media was his flair for a kind of cinematic action and movement; his pictures of galloping horses, especially those done about 1900, were much influenced by Eadweard Muybridge's research into movement using stop-motion photography. In the beginning of his career, Remington's paintings and his illustrations were, like Farny's, mostly interchangeable. However, from the late 1880s through the 1890s

fig. 15

FREDERIC REMINGTON (1861–1909)
He lay where he had been jerked, still as a log,
1893
Oil on canvas
24¼ x 36¼ inches
Gerald Peters Gallery

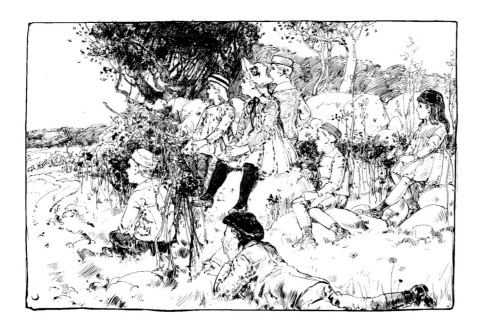

Remington successfully adopted the bright colors of Impressionism and was able to capture the searing light of the American Southwest. His painting *He lay where he had been jerked, still as a log* of 1893 (fig. 15) represents the shift to an Impressionist palette and a more broadly rendered technique (during this period he often produced work for exhibition as well as publication), yet he was not included in the anthologies of American Impressionists. Toward the end of his life, his painting took on a somber mood, tinged perhaps with regret, especially evident in his nocturnes. He died at his home in Ridgefield, Connecticut, at age forty-eight of complications following surgery.[29]

At the turn of the nineteenth century and the beginning of the twentieth, narrative painting in general was either pushed aside or significantly changed by the new movements in art, beginning with Impressionism. Traditional forms of pictorial expression were taxed to the limit by what Henry Adams has called "the eruption of forces totally new."[30] As the art of illustration for the most part adhered to older forms of the narrative, the distinction between fine art and illustration was no longer so fluid.

Unlike the paintings of Farny or Remington, Abbey or Moran, the Impressionist pictures of Hassam, Frieseke, and Metcalf were no longer a part of the narrative tradition; they did not tell a story and, as such, were quite different from their work for publication, and all three stopped illustrating as soon as they were financially able to do so. Hassam, a friend and colleague of John Twachtman, J. Alden Weir,

fig. 16

CHILDE HASSAM (1859–1935)
"So they all sat down some on big stones and the others on the grass," c. 1887
Pen and ink
11⁵⁄₁₆ x 14⅜ inches
Illustration for Margaret Sidney,
Dilly and the Captain,
Boston: D. Lothrop, 1887
Minute Man National Historical Park
Museum Collection,
Concord, Massachusetts

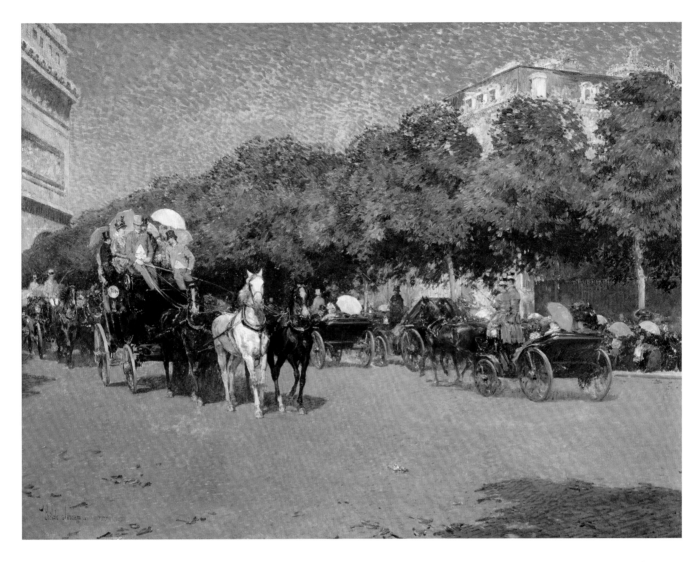

fig. 17

CHILDE HASSAM (1859–1935)
Le Jour du Grand Prix, 1887
Oil on canvas
37 x 49½ inches
New Britain Museum of American Art
Grace Judd Landers Fund, 1943.14

and Metcalf, co-founders and fellow members of the Ten American Painters, was probably the best-known American Impressionist and has often been called the "American Monet." Like Metcalf and Moran he began his career as a wood engraver and supported himself for about twenty years doing illustration work. His most famous images are his watercolors for *An Island Garden* (1894), a book of poetry written by his friend Celia Thaxter, for which he did full illustrations, "head pieces" (or chapter headings), as well as the title page, which is graced by the charming *Poppy Petals.* Hassam also illustrated children's books; a set of his line drawings from the mid-1880s for a children's book is in the possession of the National Park Service at Minute Man National Historical Park, Concord-Lexington. Given the type of historic site, it is an unusual aspect of their collection and it is not

widely known. According to Park Service records, the drawings came by gift of Miss Margaret Lothrop, presumably from the Boston publishing family, because Hassam drew an image of children on the rocks (fig. 16), one of these drawings, for a book published by D. Lothrop, *Dilly and the Captain* by Margaret Sidney. Inscribed in pencil below the image is the caption, "*So they all sat down some on big stones and the others on the grass.*" Hassam's manner of handling the figures has the easy naturalness of Homer's pictures of children done after the Civil War and argues for the point that the awkwardness of Hassam's later nudes was a deliberate expressionistic device.

While in Paris from 1886 until 1889, Hassam painted what has become his signature picture, *Le Jour du Grand Prix* of 1887 (fig. 17). Unlike many of his American colleagues there, Hassam chose to depict contemporary urban scenes. In fact, unlike most American painters in general, Hassam was one of the few who regularly used the city as a subject prior to Robert Henri and The Eight in the early twentieth century. In a way, *Le Jour du Grand Prix* is both reportorial and celebratory. It reports on the great horse race that ends the Paris season, and with its bright Impressionist palette it seems to celebrate the artist's shift from his earlier tonal painting. Rather than the race itself, Hassam casts his observant eye on the fashionable spectators who parade in their carriages along the Avenue Foch, which leads to the Bois de Boulogne and the Longchamp racetrack, where the race was held.[31]

The influence of Impressionism, both French and American, was pervasive, particularly in the use of color, evident in the work of two artists not usually associated with that style or method: Gerrit Beneker and Frank V. Dumond. A founder of the Provincetown Art Association along with Charles Hawthorne, Beneker studied at the Chicago Art Institute and the Art Students League of New York with Dumond, though the most telling influence on his work was Hawthorne. The color and handling of *The Provincetown Plumber* of 1921 reflects that influence, but the artist's sympathy with the subject was his own. Beneker made his reputation as a painter-illustrator of the workingman as well as of industry in general, which he admired and idealized. He was the perfect artist to be commissioned by the Department of the Navy in 1918 to create the immensely popular poster of a worker in a factory making war materials, *Sure, We'll Finish the Job* of 1918 (fig. 18, pg. 36), printed in more than two million copies.[32] Dumond was associated with the well-known artists' colony in Old Lyme, Connecticut. *Autumn, Grassy Hill*, painted at his Connecticut farm, has Impressionist color, but in its modified Impressionist approach and

fig. 19

HENRY McCARTER (1864–1942)
The Witch Wife, 1911
Pen and ink
21½ x 6 inches
Illustration for *Century Magazine*, April 1911
Kelly Collection of American Illustration

As an illustrator Hopper specialized in pictures of offices, ships, and railroads; hotel and restaurant scenes; and the theater—themes that were also important in his later painting.

"A [modern] work of art is never a picture of something," wrote Stuart Davis. "It always is something. My French pictures are not interesting as pictures of Paris, but as ordered objects. This is fundamental."[37] With the philosophical premise of the work of art as object, the distinction between fine easel painting and illustration became more obvious. The two modernists in the exhibition, Lyonel Feininger and Henry McCarter, painted "ordered objects," not narrative, especially compared to Jacob Lawrence, whose work was driven by the narrative element. Lawrence is best known for his paintings of African-American life done in a style that blends Cubism with naive, or folk art, such as the *Great Migration Series* (1940–41; Museum of Modern Art, New York), showing the movement of African Americans from southern farms to northern cities. Lawrence did some illustrating—particularly notable is Aesop's *Fables*—but, like the work of John Quidor, Lawrence's painting, because of its narrative content, is also a combination of fine-arts easel painting and illustration.[38]

The "ordered objects" of Henry McCarter, such as *Bells, No. 6* of 1940, are miles apart from his work for publication. In this series McCarter tried to capture the sound of bells in visual terms, employing abstraction and a Fauvist palette. His illustration *The Witch Wife* done for *Century Magazine* (fig. 19) is reminiscent of the illustrations of Frank Dumond. McCarter taught at the Pennsylvania Academy for almost as long as Dumond taught at the Art Students League, and there was more of a link between his painting and teaching than there was between his illustration and painting. His illustrations are often very fine, but they were a means of financial support. McCarter was an enthusiastic admirer of Pierre Matisse and passed along that admiration, as well as his knowledge of modernist color, to his students. One of his students, Arthur Carles, was among the best colorists of his generation. Like his teacher and mentor, he deserves to be better known.

Lyonel Feininger is best known as a painter and a founder of the Bauhaus, which opened in Weimar in 1919. Works such as *Possendorf (Village Church)* of 1929 are semi-abstract landscapes done in a Cubist-Futurist manner in an unmistakable style. Less well known is his role in the history of the comic strip. Born in New York to German parents, Feininger studied art at the Berlin Academy in 1888 and sold his first cartoon in 1889. His early influences included the famous German car-

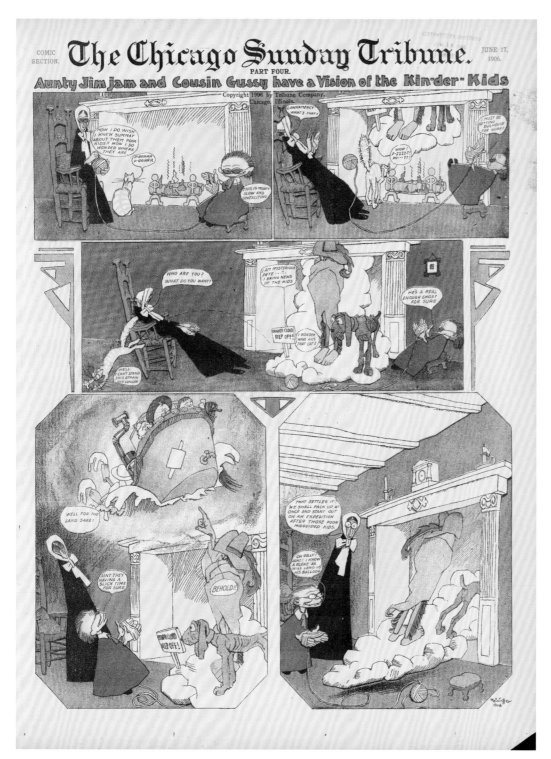

fig. 20

LYONEL FEININGER (1871–1956)
Kin-der-Kids, 1906
Tear sheet for *Chicago Sunday Tribune*, June 17, 1906
San Francisco Academy of Comic Art Collection
The Ohio State University Cartoon Research Library

toonist Wilhelm Busch and the American illustrator Arthur Burdett Frost. In the United States, Feininger's illustrations were published in *Harper's Young People* and *St. Nicholas.* In 1906 he met James Keeley, art editor of the *Chicago Tribune*, who was interested in the work of German comic artists. Comics and cartoons helped sell newspapers, and Keeley was interested in doing something new in the medium. Feininger agreed to produce two comic strips for the *Tribune*, one of which was *Kin-Der-Kids*, which appeared on April 29, 1906. *Kin-Der-Kids* (fig. 20, pg. 39) relates the adventures of a very strange group of children and has a kind of Surrealist quality; the color and layout are unusual, as are the decorative elements in between panels. Feininger was ahead of his time with his experimental designs and themes of rebellion and anarchy. Although the comic strip was cancelled, Feininger continued with another entitled *Wee Willie Winkie* through 1907.[39]

As illustration became more focused as an art created for reproduction—a loaded word—the separation between the two professions was complete. "An illustrator creates art for reproduction," stated the illustrator and teacher, Murray Tinkelman. "The intent is paramount. The viewing public sees the reproduction, not the original. . . . A more accurate description of an illustration might be a work of art where the original is the reproduction."[40]

In the late nineteenth century critics invariably compared illustration and fine-art painting. William Hobbs saw painting as aiming to please one's eye and aesthetics, whereas illustration sought to please the intellectual faculties already addressed by the text. "Illustration's primary function," he stated "is to illuminate the text."[41] Another critic of the time wrote, "For winning the heart of the American people, we must turn to illustration, a field which is perhaps on a lower plane than some branches of painting, but which requires the keenest perception of detail and the most facile handling of human nature and its surroundings."[42] Because of the criticism that it was on a "lower plane," as well as its commercial associations, many artists avoided it altogether or left off as soon as they were able, as was the case with Metcalf. Ellen Emmet Rand did not want it known that she had done some illustrating to make money, and even N. C. Wyeth had doubts, often feeling conflicted about illustration work and questioning its value compared to that of easel painting. This conflict is brilliantly outlined by James H. Duff in *Not for Publication: Landscapes, Still Lifes, and Portraits by N. C. Wyeth*, the catalogue accompanying the exhibition held at the Brandywine River Museum in 1982.

fig. 21

N. C. WYETH (1882–1945)
Dying Winter, 1934
Oil on canvas
42¼ x 46⅜ unframed
47⅜ x 51⅜ framed
Brandywine River Museum
Museum purchase, 1982
82.11

Wyeth was perhaps one of the most popular illustrators of his day and beyond. His illustrations always had a sense of the dramatic, and in 1903 he first made his name with Western subjects. As early as 1905, however, he saw a widening gap between illustration and painting, so he tried to divide his time between the two. His sensitive rendering of the Chadds Ford landscape in the elegiac *Dying Winter* of 1934 (fig. 21) is representative of his independent work on canvas. Yet his most powerful works, such as *Blind Pew* of 1911 (Brandywine River Museum) and *At the Cards in Cluny's Cage* of 1913, with their dramatic use of light and color, were his illustrations.

More recently, the term "illustrator" has often been used as a sort of "Scarlet I," which is unfortunate, as it tends to obscure the true dif-

ferences and similarities between the two disciplines. "The greatest artists have not neglected illustration. With them it was another form of creative expression." Like Rockwell Kent, who created unforgettable images in both his paintings and illustrations, "their drawings for books contain all of the abstract qualities of design that distinguishes their other works."[43] The tension between the two disciplines can also probably be laid at the door of the position of the artist in American society as well—its problematic character, its uncertainty. "The painter and his art," wrote David Rosand, "faced a continuing ambivalence of purpose and insecurity of position."[44] There was also an antipathy toward works done for reproduction (with the exception of original prints). That, in addition to the adaptation of modernist thinking, could lead to an essentially negative attitude. In any case, it is a theme that needs to be explored further.

In 1895 the first motion pictures made their appearance in France and the United States. The moving image was based upon a

fig. 22

THOMAS HART BENTON
(1889–1975)
Portrait of Denys Wortman, 1953
Oil on canvas mounted on board
32 x 40 inches
New Britain Museum of American Art
Stephen B. Lawrence Fund, 1954.01

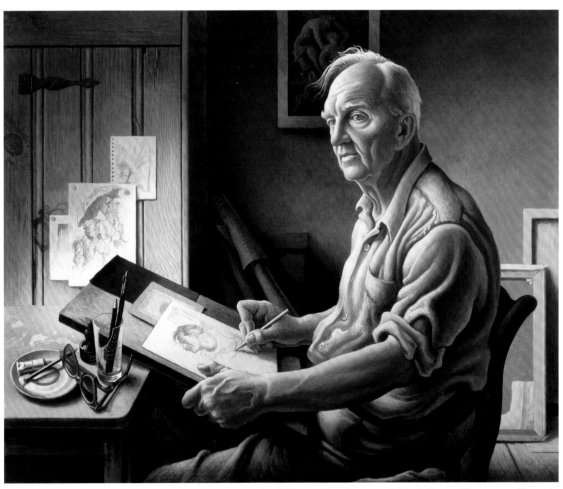

series of image-by-image photographs. The comic strip appeared at approximately the same time: 1889 in France and 1894 in the United States. As a matter of fact, the motion picture, the comic strip, and the animated cartoon appeared at roughly the same time, but it was the motion picture that had, perhaps, the biggest impact on the narrative tradition, and illustration had its own impact on the making of motion pictures, as previously noted in connection with Remington and Ford.

The motion picture replaced history painting and the kind of narrative that Abbey and Pyle and his students used to make; in that sense, it was illustration, albeit illustration in motion. It became "a recently invented and mechanically sophisticated tool to aid men in their desire to make pictures. Of all the arts of communication that man has learned . . . pictures seem to take a special place . . . the picture is a basic form of communication." And in the words of Richard Chalfen, "The use of a motion picture camera was a new way of making pictures."[45]

A number of artists had a connection with motion pictures in one way or another, and illustrators were notable for their accuracy in depicting period costume and accessories as well as for their dramatic use of light and shade and their choice of just the right moment in the flow of the written narrative to illuminate. Edwin Austin Abbey, in particular, was known for his carefully researched period costumes

fig. 23

GRANT WOOD (1891–1942)
Sentimental Ballad, 1940
Oil on masonite
24 x 50 inches
New Britain Museum of American Art
Charles F. Smith Fund, 1962.01

and archaeologically accurate props and sets, which he kept in his studio in Gloucestershire, England. In early American cinema D. W. Griffith, Douglas Fairbanks, and Cecil B. DeMille come to mind, and who better was there to turn to for models than such illustrators as Pyle, Abbey, and Wyeth. Like early photography, early filmmaking drew upon the one art form closest to it: painting. "Whenever we saw a painting "with an interesting light," said the film director Clarence Brown, "we'd copy it. We had a library of pictures."[46]

Thomas Hart Benton's general style of painting and illustration was of a piece. His illustrations *Open Hearth* and *Little Cotton Pickers*, done in 1929 for his book *An Artist in America*, are not substantially different in style from the *Portrait of Denys Wortman* done in 1953. *Portrait of Denys Wortman* (fig. 22, pg. 42) was executed in tempera, which Benton was inspired to use from observing scene painters. At loose ends in 1914, he began designing sets and backdrops for Rex Ingram, a friend who became a film director. "I became interested in 'distemper,'" he said, "or glue painting . . . and from this time on, I would continue to experiment . . . it would lead to the egg-tempera techniques I used for my murals in the thirties." The Hollywood producer Walter Wanger hired him to paint scenes from films.[47]

Along with Benton and John Steuart Curry, Grant Wood developed a new style of Realist painting and subject matter that came to be called "Regionalist"; *Haying* of 1939 is a superb example. Its stylized Realism combines aspects of modernism with American scene painting. The illustration *Sentimental Ballad* of 1940 (fig. 23, pg. 43) is less stylized and is of interest because of its background. Like Benton, Raphael Soyer, and six other leading painters,[48] Wood was lured to Hollywood in 1940 by Walter Wanger to illustrate scenes from his film production of Eugene O'Neill's *The Long Voyage Home* directed by John Ford. Painted from photographs and film stills, the portraits of the seven actors were ambitious for Wood. The paintings from the film were conceived as a publicity stunt, but they received a lot of public attention and were perhaps a new way of developing collaborations between artists and filmmakers. Ford, himself, originally wanted to be a painter, and the framing of his shots was influenced by a painterly use of composition; many of his Westerns were influenced by the action and color in Remington's paintings.

Beginning in the 1920s N. C. Wyeth also had a connection with the making of movies.

As revealed in Wyeth's letter to his father of March 24, 1926, Douglas Fairbanks wanted Wyeth to work with him, but Wyeth soon backed out and his friend Dwight Franklin, who was an authority on period costumes, took his place. In the same letter he describes meeting the documentary filmmaker Robert Flaherty, who wanted Wyeth to be his assistant director on a film about the Hudson's Bay Company, a project that never materialized.[49] One of the best examples of the relationship between Wyeth's paintings and the movies came about during the filming of *The Yearling* (1948), directed by Clarence Brown, in which seven of Wyeth's illustrations were used as the basis for key scenes. The film still of *Penny Tells the Story of the Bear Fight* (pg. 70) is on view along with the illustration from the 1939 special edition of the book.

In looking at the differences and similarities between the art of illustration and the art of independent easel painting and in comparing both by the same artist, it might be said that the relationship between illustration and fine art is the same as that between prose and poetry. Color, shape, and draftsmanship (the abstract qualities of design) are the tools of both the fine artist and the illustrator, just as words are the tools of both the writer of prose and the writer of poetry. Narrative is of major importance to illustration, while a work of fine art is often a personal expression of an internal rhythm, like the meter of a poem. In terms of quality there are exciting works of fine art, as there are those that are routine; there are exciting illustrations and those that are simply workman-like. One important respect in which illustration differs from other forms of visual art is that its completed state is not the work of the artist's hand but rather its final published form. Many of the illustrations in this exhibition were but an intermediate step in the final process of the completed and published illustration. Dependent on the interpretation of the publisher and the prevalent print technology, the final form can be an accurate treatment of the illustrator's original intention or a travesty upon it. So, these examples of the original intention of the artist are what collectors and museums generally acquire. Nevertheless, it is important to be aware that these works were intended to be seen on the printed page rather than framed and hung on the wall, but that makes them no less enjoyable or interesting.

Richard J. Boyle
Salisbury, Connecticut, and Chinon, France

Notes

1. George Howe Colt, *The Big House: A Century in the Life of an American Summer House* (New York: Scribner, 2003), pp. 233–34; James K. Ballinger, *Frederick Remington* (New York: Harry N. Abrams in association with the National Museum of American Art, Smithsonian Institution, Washington, D.C., 1989), p. 150.

2. When I offered to teach a course in the history of illustration at the University of the Arts in Philadelphia, the chairperson of the department told me that it was not art history. It was an odd attitude, especially in an art school with a strong illustration department and a teaching tradition that can be traced back to Howard Pyle! Admittedly, that was more than twenty-five years ago. Yet today, while there are good anthologies and specialist studies of book illustration, there still are no histories of illustration (with the possible exception of Michel Melot's *The Art of Illustration* [New York: Skira/Rizzoli, 1984]) comparable to those on the fine arts, and in those histories of the fine arts, illustration is rarely mentioned.

3. Estelle Jussim, *Visual Communication and the Graphic Arts* (New York and London: R. R. Bowker, 1974), p. 81.

4. Kurt Weitzmann, quoted in Melot, *The Art of Illustration*, pp. 27, 83.

5. See Pierre Couperie et al., *A History of the Comic Strip*, trans. Eileen B. Hennessy (New York: Crown Publishers, 1968), p. 7.

6. See Ellen Mazur Thomson, *The Origins of Graphic Design in America, 1870–1920* (New Haven and London: Yale University Press, 1997), pp. 13–14.

7. Ibid., p. 23.

8. Ibid., p. 75.

9. Ibid., p. 12.

10. See Alexandra Bonfante-Warren, *Currier & Ives: Portraits of a Nation, Featuring Currier & Ives Prints from the Collection of the Museum of the City of New York* (New York: MetroBooks, 1998), n.p.

11. See Philip Beam and Lindsley Wellman, *Winslow Homer's America: Wood Engravings* (New Britain: New Britain Museum of American Art, 2003); and Helen Ashton Fisher, *Winslow Homer—A Collector's Passion: Works from the Arkell Museum at Canajoharie* (Rockland, Me.: Farnsworth Art Museum, 2006).

12. Conversations with Sarah Getz, the artist's daughter, since 2006.

13. Melot, *The Art of Illustration,* p. 117; in the United States in the late nineteenth century, Howard Pyle would espouse that very principle in his work and teaching.

14. Philip B. Meggs, *A History of Graphic Design* (New York, John Wiley & Sons, 1998), pp. 153–54.

15. See Neal Gabler, *Life the Movie: How Entertainment Conquered Reality* (New York: Alfred A. Knopf, 1999), p. 53.

16. Quoted in J. Hillis Miller, *Illustration* (Cambridge: Harvard University Press, 1992), pp. 61, 68–69.

17. See Gabler, *Life the Movie,* pp. 53, 54; and E. L. Godwin, "Reflections and Comments, 1865–1895," *Scribner's* (1895): 201–5.

18. See Miller, *Illustration,* pp. 25, 31.

19. Professor Richard H. Chalfen, Professor of Visual Anthropology, email, May 16, 2006.

20. Couperie et al., *History of the Comic Strip,* p. 229.

21. Quoted in Thomson, *Origins of Graphic Design,* p. 69.

22. Donelson Hoopes, *American Narrative Painting* (Los Angeles and New York: Los Angeles County Museum of Art, in association with Praeger Publishers, 1974), p. 15.

23. See Kathleen A. Foster and Michael Quick, *Edwin Austin Abbey* (New Haven: Yale University Art Gallery, 1974).

24. See Joanna Drucker, *The Century of Artists' Books* (New York: Granary Books, 1996).

25. Henry Adams et al., *John LaFarge* (Washington, D.C., and New York: National Museum of American Art, Smithsonian Institution, and Abbeville Press, 1987). Tennyson's poem *Enoch Arden* was also the basis for an important innovation in the history of film; D. W. Griffith adapted it as a successful two-reeler in 1911, which changed the course of filmmaking; see Timothy Corrigan, *Film and Literature: An Introduction and Reader* (Upper Saddle River, N.J.: Prentice Hall, 2000), p. 21.

26. Elizabeth DeVeer and Richard J. Boyle, *Sunlight and Shadow: The Life and Art of Willard L. Metcalf* (New York: Abbeville Press for Boston University, 1987); and Richard J. Boyle, "Willard Metcalf," in William H. Gerdts et al., *The Ten American Painters* (New York: Spanierman Gallery, 1997), pp. 109–11.

27. Cincinnati Art Museum, *The Golden Age: Cincinnati Painters of the Nineteenth Century Represented in the Cincinnati Art Museum* (Cincinnati, 1979), pp. 25, 71, 73.

28. Ballinger, *Frederick Remington,* p. 150.

29. Quoted in John H. Lienhard, *Inventing Modern: Growing Up with X-Rays, Skyscrapers, and Tailfins* (New York: Oxford University Press, 2003), p. 38, n. 18. The full quote: "I found myself lying in the Gallery of Machines, my historical neck broken by the eruption of, etc. etc."

30. Kathleen Burnside, Hassam scholar, email, August 3, 2006; curatorial information from *Minute Man National Historical Park,* Concord-Lexington, Mass.

31. See *Gerrit A. Benecker (1882–1934): Painter of American Industry* (Boston: Vose Galleries of Boston, 1988).

32. See Jeffrey W. Andersen, *The Harmony of Nature: The Art and Life of Frank Vincent Dumond, 1865–1951* (Old Lyme: Florence Griswold Museum, 1990).

33. Gail Levin, *Edward Hopper as Illustrator* (New York: Whitney Museum of American Art, 1979), p. 1.

34. Ibid., p. 2.

35. Ibid.

36. Stuart Davis, April 2, 1940, *Stuart Davis Papers*, Fogg Art Museum, Harvard University Art Museums, Cambridge; quoted in Mary Birmingham, "Dynamic Impulse: The Drawings of Stuart Davis," *Dynamic Impulse: The Drawings of Stuart Davis* (New York: Hollis Taggart Galleries, 2007), p. 9, n. 6.

37. "Jacob Lawrence—Aesop's Fables," April 10–June 20, 1999, Hood Museum of Art, Dartmouth College.

38. See Bill Blackbeard, ed., *The Comics of Lyonel Feininger* (Seattle: Fantagraphics Books, 2007); see also the cartoon collection of Ohio State University, http://cartoons.osu.edu.

39. Interview with Murray Tinkelman, March 3, 2008.

40. William Herbert Hobbs, "Art as the Handmaid of Literature," *Forum* (May 1901): 371–72.

41. Philip Rodney Paulding, "Illustrators and Illustrating," *Munsey's* (May 1895): 152; see also William Ayres et al., *Picturing History: American Painting, 1770–1930* (New York: Rizzoli, in Association with Fraunces Tavern Museum, 1993).

42. Howard Simon, *500 Years of Art in Illustration: From Albrecht Dürer to Rockwell Kent* (Cleveland and New York: World Publishing Company, 1947), p. xiii.

43. David Rosand, *The Invention of Painting in America*. The Leonard Hastings Schoff Memorial Lectures (New York: Columbia University Press, 2004), pp. 69–70; see also Neil Harris, *The Artist in American Society: The Formative Years, 1790–1860* (New York: George Braziller, 1966), p. viii.

44. Sol Worth, in Sol Worth and John Adair, *Through Navajo Eyes: An Exploration in Film Communication and Anthropology* (Albuquerque: University of New Mexico Press, 1997), pp. 24–25, 81.

45. Quoted in David Michaelis, *N. C. Wyeth: A Biography* (New York: Alfred A. Knopf, 1998), p. 274.

46. Richard Boyle et al., *Milk and Eggs: The Revival of Tempera Painting in America, 1930–1950* (Chadds Ford and Seattle: Brandywine River Museum and University of Washington Press, 2002), pp. 27, 206.

47. N. C. Wyeth's letter of March 24, 1926, is published in Betsy James Wyeth, ed., *The Letters of N. C. Wyeth* (Boston: Gambit, 1971), pp. 717–23. My thanks to Christine Podmaniczky, Associate Curator, N. C. Wyeth Collection at the Brandywine River Museum, for her invaluable help.

DOUBLE LIVES

COLOR PLATES

EDWIN AUSTIN ABBEY (1852–1911)
Organist at the Gloucester Cathedral, c. 1901
Oil on canvas
24 x 20⅛ inches
New Britain Museum of American Art
Gift of the Harrison Cady Estate, 1971.29

FIDELIA BRIDGES (1834–1923)
Bird in Thicket, n.d.
Oil on canvas
18 x 14 inches
Kronholm Family

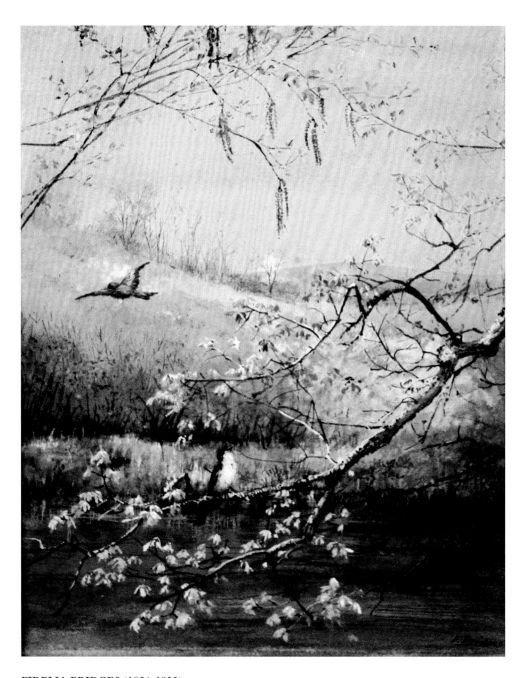

FIDELIA BRIDGES (1834–1923)
Apple Blossoms, n.d.
Watercolor on paper
9¾ x 7¾ inches
Kronholm Family

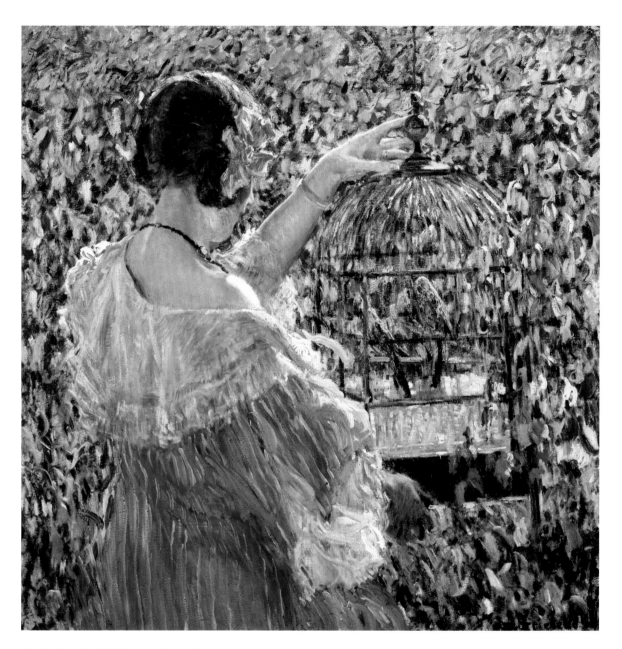

FREDERICK FRIESEKE (1874–1939)
The Bird Cage, c. 1910
Oil on canvas
32 x 32 inches
New Britain Museum of American Art
John Butler Talcott Fund, 1917.2

FREDERICK FRIESEKE (1874–1939)
Miss Chromatic's Singing, c. 1897
Pen and ink on paste board
11⅛ x 13⅞ inches
Courtesy of Nicholas Kilmer

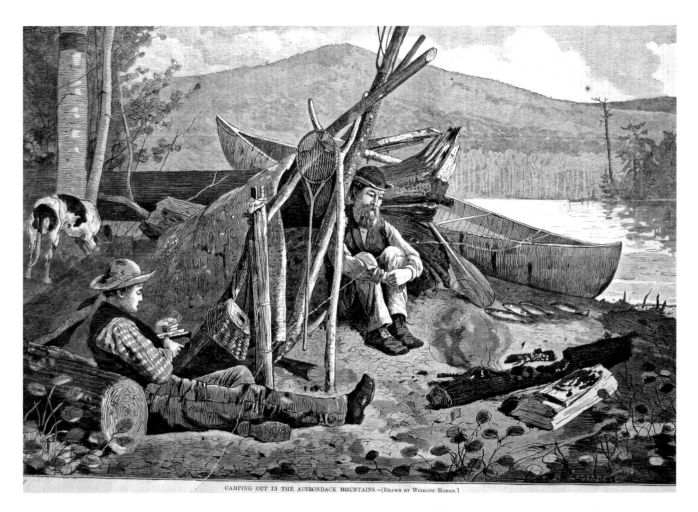

CAMPING OUT IN THE ADIRONDACK MOUNTAINS.—[Drawn by Winslow Homer.]

WINSLOW HOMER (1836–1910)
Camping Out in the Adirondack Mountains
Woodblock
Illustration for *Harper's Weekly*, November 7, 1874
9⅛ x 13¼ inches
JULI Collection of Judith Vance Weld Brown and
Lindsley Wellman, New Britain, Connecticut, promised
gift to the New Britain Museum of American Art

REGINALD MARSH (1898–1954)
"On these adventures we always went very well dressed," c. 1942
Pen and ink on paper
8½ x 11 inches
Illustration for Daniel Defoe, *The Fortunes and Misfortunes of the Famous Moll Flanders,*
New York: Heritage Press, 1942
Brandywine River Museum
Museum Volunteers' Purchase Fund, 1984
84.8

THOMAS MORAN (1837–1926)
The Wilds of Lake Superior (Western Landscape), 1864
Oil on canvas
30⅛ x 45⅛ inches
New Britain Museum of American Art
Charles F. Smith Fund, 1944.04

THOMAS MORAN (1837–1926)
View from Glenora, Stickeen River, Alaska, 1879
Carbon pencil and ink on textured paper
7¼ x 5⅞ inches
Illustration for W. H. Bell, "View from Glenora, Stickeen River,
Alaska," *Scribner's Monthly*, April 1879.
Brandywine River Museum
Purchased with funds given in memory of Eloise W. Choate
and other funds, 2004
2004.6

SOCIETY NOTE—DOG DAYS IN FEBRUARY

ELLEN EMMET RAND (1874–1941)
Dog Show, c. 1890s
Pen and ink on paper
12½ x 18 inches
Illustration for *Vogue*, c. 1890s
Ellen E. Rand

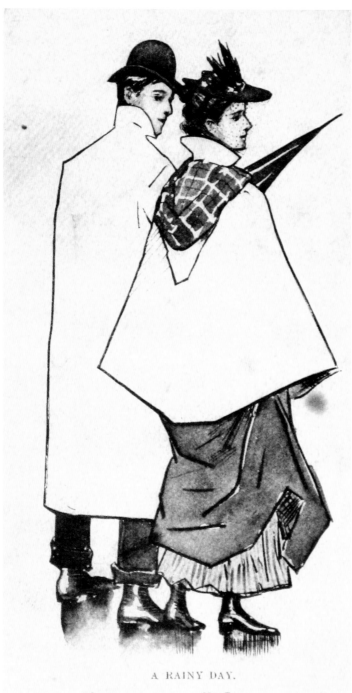

A RAINY DAY.

"Look at that foolish Mr. Baker out on a day like this without an umbrella. Is he crazy?"
"I'm afraid he is. Let's hurry on. I don't want to meet him."
"Why not?"
"He may recognize this umbrella. It's his."

ELLEN EMMET RAND (1874–1941)
Rainy Day, c. 1890s
Watercolor on paper
6½ x 3 inches
Illustration for *Vogue* or *Harper's*,
c. 1890s
Ellen E. Rand

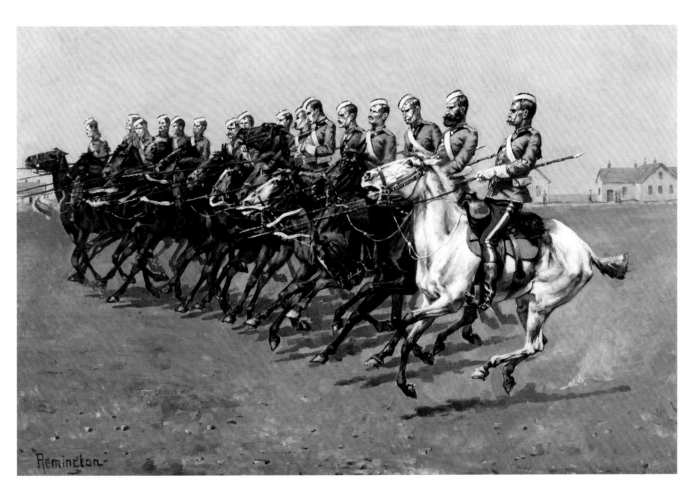

FREDERIC REMINGTON (1861–1909)
The Canadian Mounted Police on a
"Musical Ride" – "Charge!" 1887
15¼ x 23½ inches
Oil on academy board
Brandywine River Museum
Museum Purchase, 1988
88.18.1

FREDERIC REMINGTON (1861–1909)
They Were a Hard Looking Set, 1887
Ink on paper
Illustration for John Bigelow, "After Geronimo,"
Outing Magazine, March 1887
Brandywine River Museum
Gift of Catherine Auchincloss, 1989
89.7

BEN SHAHN (1898–1969)
Inside Looking Out for Seventeen Magazine, 1953
Casing on panel
17 x 15 inches
The Butler Institute of American Art, Youngstown, Ohio
Museum Purchase, 1953

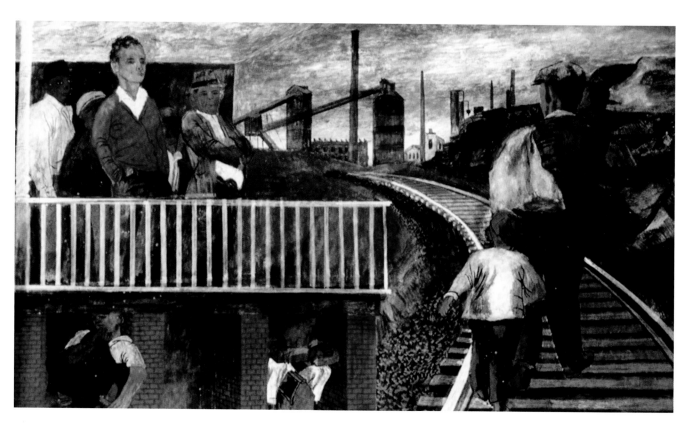

BEN SHAHN (1898–1969)
Sketch for mural in the Social Security Building, c. 1940–42.
Tempera on paper
8¾ x 15½ inches
Collection of Rhoda and David T. Chase

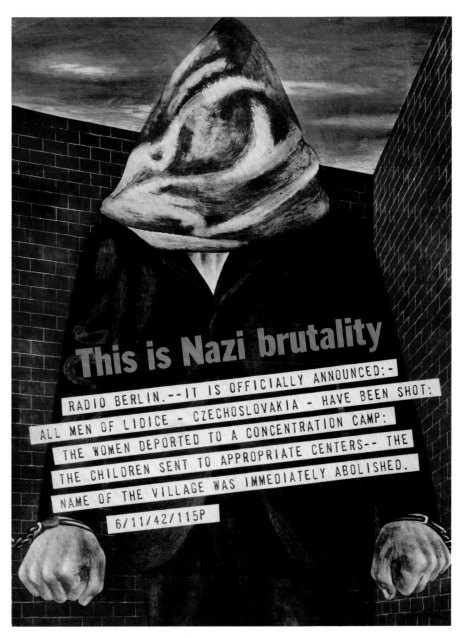

BEN SHAHN (1898–1969)
This is Nazi Brutality, 1943
Offset lithograph
40⅛ x 28¼ inches
The Museum of Modern Art, New York
Gift of the Office of War Information
107.1944.

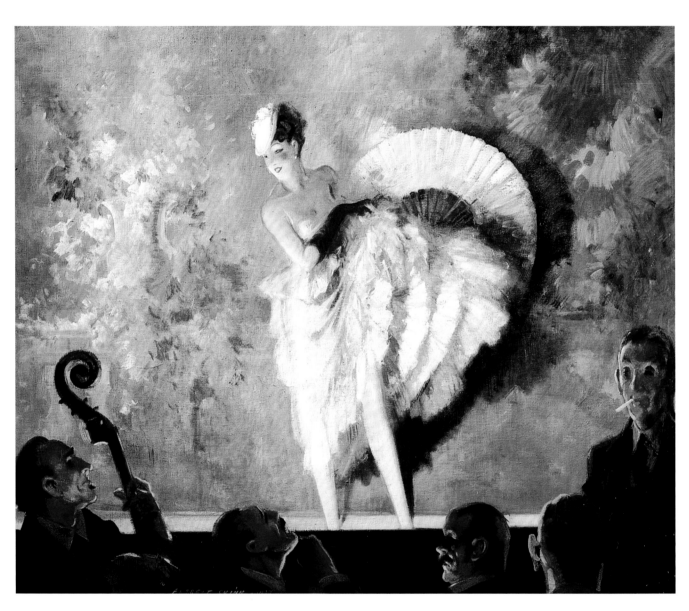

EVERETT SHINN (1876–1953)
French Vaudeville, 1937
Oil on canvas
25⅛ x 30⅛ inches
New Britain Museum of American Art
Harriett Russell Stanley Fund, 1946.22

EVERETT SHINN (1876–1953)
Mr. Fezziwig's Ball, 1938
Watercolor on paper
4 x 7⅛ inches
Unpublished illustration for Charles Dickens, *A Christmas Carol in Prose*
(New York: Garden City Publishing Co., 1938).
Brandywine River Museum.
The Jane Collette Wilcox Collection, 1982
82.16.247

N. C. WYETH (1882–1945)
Penny Tells the Story of the Bear Fight
Movie still from Clarence Brown's *The Yearling*, MGM, 1946
8¼ x 8¼ (framed dim approx 9¼ x 9¼ inches)
Photofest Film Stills Archive
Courtesy of Photofest

Checklist

ARTISTS ARE LISTED ALPHABETICALLY

Height precedes width

EDWIN AUSTIN ABBEY (1852–1911)
And Strove the Maids to Win (Soldier and Peasant Girl), 1881
Ink on paper
Illustration for Annie Fields, "Pastor Dankwardt,"
Harper's New Monthly Magazine, January 1882
Brandywine River Museum
Gift of Mr. and Mrs. Frank Fowler, 1978
78.22.5
See page 27

EDWIN AUSTIN ABBEY (1852–1911)
May Day Morning, 1890–94
Oil on canvas
59 x 84 inches framed
Yale University Art Gallery
Edwin Austin Abbey Memorial Collection

EDWIN AUSTIN ABBEY (1852–1911)
Organist at the Gloucester Cathedral, c. 1901
Oil on canvas
24 x 20⅛ inches
New Britain Museum of American Art
Gift of the Harrison Cady Estate, 1971.29
See page 9, 50

GERRIT BENEKER (1882–1934)
The Provincetown Plumber, 1921
Oil on canvas
32 x 30 inches
Provincetown Art Association and Museum Collection
Gift of Alfred Morris

GERRIT BENEKER (1882–1934)
Sure We'll Finish the Job, 1918
Liberty Loan poster
40 x 30 inches
Collection of Katrina Beneker
See page 36

THOMAS HART BENTON (1889–1975)
Little Cotton Pickers, 1929
Pen ink and wash on paper
Illustration from Benton's *An Artist in America*, published 1937
11 x 14 inches
John and Kay Callison Collection

THOMAS HART BENTON (1889–1975)
Open Hearth, 1929
Pen ink and wash on paper
Illustration from Benton's *An Artist in America*, published 1937
9 x 12 inches
John and Kay Callison Collection

THOMAS HART BENTON (1889–1975)
Portrait of Denys Wortman, 1953
Oil on canvas mounted on board
32 x 40 inches
New Britain Museum of American Art
Stephen B. Lawrence Fund, 1954.01
See page 42

ROBERT BLUM (1857–1903)
Master Will You Condescend (Rickshaw Men)
Pen and ink on paper, 13⅞ x 9⅞ inches
Robert Blum, "An Artist in Japan". *Scribners*, June 1893.
Brandywine River Museum
The Jane Collette Wilcox Collection, 1982
82.16.17
See page 19

ROBERT BLUM (1857–1903)
Two Idlers, 1888–89
Oil on canvas
29 x 40 inches
National Academy of Design

FIDELIA BRIDGES (1834–1923)
Apple Blossoms, n.d.
Watercolor on paper
9¾ x 7¾ inches
Kronholm Family
See page 52

FIDELIA BRIDGES (1834–1923)
Bird in Thicket, n.d.
Oil on canvas
18 x 14 inches
Kronholm Family
See page 11, 51

NATHANIEL CURRIER (1813–1888), publisher
Drawn by William K. Hewitt (1813–1893)
The Awful Conflagration of the Steamboat "Lexington" in Long Island Sound,
1840 Photographic reproduction of color lithograph
The Museum of the City of New York

FRANK V. DUMOND (1865–1951)
At Sleeping Water, n.d.
Oil on canvas
Illustration for *Century Magazine*, July 1900
7 x 13 inches
Courtesy of Illustration House, NY

FRANK V. DUMOND (1865–1951)
Grassy Hill, 1920
Oil on canvas
23⅝ x 29½ inches
Florence Griswold Museum
Gift of Elisabeth DuMond Perry

FRANK V. DUMOND (1865–1951)
Title page design, *Harper's New Monthly Magazine*, Christmas, 1896
Blue ink on paper highlighted with gold
Museum of American Illustration at the Society of Illustrators

GEORGE DURRIE (1820–1863)
Winter in the Country: A Cold Morning, 1867
Hand-colored lithograph
Museum of Fine Arts, Springfield, Massachusetts
Gift of Lenore B. and Sidney A. Alpert supplemented with Museum
Acquisitions Funds

GEORGE DURRIE (1820–1863)
Winter in New England, 1851
Oil on panel
19⅞ x 25 inches
New Britain Museum of American Art
Stephen B. Lawrence Fund, 1958.11
See page 14

HENRY FRANCIS FARNY (1847–1916)
Indian Frontiersmen, Dogsled and Team, before 1894
Pen and ink on paper
6¼ x 11 inches (unframed)
Brandywine River Museum
Museum Purchase, 2004
See page 30

HENRY FRANCIS FARNY (1847–1916)
Last Stand of the Patriarch, 1906
Watercolor and gouache
13¼ x 22½ inches (unframed)
21¼ x 29 inches (framed)
Private Collection
See page 31

LYONEL FEININGER (1871–1956)
Kin-der-Kids, 1906
Tear sheet for *Chicago Sunday Tribune*, June 17, 1906
San Francisco Academy of Comic Art Collection
The Ohio State University Cartoon Research Library
See page 39

LYONEL FEININGER (1871–1956)
Possendorf (Village Church), 1929
Oil on canvas
30⅝ x 38⅝ inches
Pennsylvania Academy of the Fine Arts, Philadelphia
Henry D. Gilpin Fund, 1951

FREDERICK FRIESEKE (1874–1939)
Miss Chromatic's Singing, c. 1897
Pen and ink on paste board
11⅛ x 13⅞ inches
Courtesy of Nicholas Kilmer
See page 54

FREDERICK FRIESEKE (1874–1939)
The Bird Cage, c. 1910
Oil on canvas
32 x 32 inches
New Britain Museum of American Art
John Butler Talcott Fund, 1917.02
See page 5, 53

ARTHUR GETZ (1913–1996)
Diner at Night (A Tribute to Edward Hopper), c. 1950
Oil on canvas
28½ x 48 inches
Sarah Getz Collection
See page 23

ARTHUR GETZ (1913–1996)
52nd Street Strip Joint, c. 1950–51
Casein tempera on Whatman paper mounted on chip board,
24 x 18 inches
Illustration for cover of *The New Yorker*, May 19, 1951
Sarah Getz Collection

WILLIAM GLACKENS (1870–1938)
Patrick Joseph Went and Bought Himself a Grocery Store on Monroe Street
Illustration for E. R. Lipsett, "Denny the Jew," *Everybody's Magazine*, vol. 27,
no. 1, July 1912
Ink and graphite on board
22¹¹⁄₁₆ x 15⅞ inches
Brandywine River Museum
The Jane Collette Willcox Collection, 2003
2003.2.3
See page 20

WILLIAM GLACKENS (1870–1938)
Washington Square Winter, 1910
Oil on canvas
25 x 30 inches
New Britain Museum of American Art
Charles F. Smith Fund, 1944.3
See page 21

CHILDE HASSAM (1859–1935)
Le Jour du Grand Prix, 1887
Oil on canvas
37 x 49½ inches
New Britain Museum of American Art
Grace Judd Landers Fund, 1943.14
See page 34, cover

CHILDE HASSAM (1859–1935)
"So they all sat down some on big stones and the others on the grass," c. 1887
Pen and ink
11⁵⁄₁₆ x 14⅜ inches
Illustration for Margaret Sidney, *Dilly and the Captain,*
Boston: D. Lothrop, 1887
Minute Man National Historical Park Museum Collection,
Concord, Massachusetts
See page 33

WINSLOW HOMER (1836–1910)
Camping Out in the Adirondack Mountains
Woodblock
Illustration for *Harper's Weekly*, November 7, 1874
9⅛ x 13¼ inches
JULI Collection of Judith Vance Weld Brown and Lindsley Wellman,
New Britain, Connecticut, promised gift to the New Britain Museum
of American Art
See page 55

WINSLOW HOMER (1836–1910)
News From the War, 1862
Wood engraving
Illustration for *Harper's Weekly*, June 14, 1862
20¼ x 13¼ inches
New Britain Museum of American Art
William F. Brooks Fund, 1977.01.21
See page 17

WINSLOW HOMER (1836–1910)
Skirmish in the Wilderness, 1864
Oil on canvas
18 x 26¼ inches
New Britain Museum of American Art
Harriet Russell Stanley Fund, 1944.05
See page 18

ROCKWELL KENT (1882–1971)
Seascape, 1933–35
Oil on canvas
34⅛ x 44 inches
Pennsylvania Academy of the Fine Arts, Philadelphia
Gift of Erhard Wayne, 1952
1952.1

ROCKWELL KENT (1882–1971)
The Whale as a Dish, 1930
Pen and ink on paper
Illustration for Chapter 65, Herman Melville, *Moby Dick*,
Chicago: Lakeside Press, 1930
7 x 4 inches
Museum of American Illustration at the Society of Illustrators

JOHN LA FARGE (1835–1910)
9 Illustrations for *Enoch Arden*, 1864
Wood engraving on paper
Alfred Lord Tennyson, *Enoch Arden*, published by Ticknor and Field,
Boston in 1864
Collection of Henry Adams

The Children
3$\frac{7}{16}$ x 3$\frac{15}{16}$ inches

Enoch Alone
3$\frac{7}{8}$ x 3$\frac{1}{4}$ inches

Enoch's Supplication
3$\frac{3}{16}$ x 3$\frac{11}{16}$ inches

The Island Home
3$\frac{13}{16}$ x 3$\frac{1}{4}$ inches

The Lovers
3$\frac{15}{16}$ x 3$\frac{1}{8}$ inches

Philip and Annie in the Wood
3$\frac{5}{16}$ x 3$\frac{15}{16}$ inches

The Seal of Silence
3$\frac{15}{16}$ x 2$\frac{9}{16}$ inches

Shipwrecked
3$\frac{15}{16}$ x 4 inches

The Solitary
3$\frac{15}{16}$ x 3$\frac{3}{8}$ inches

JOHN LA FARGE (1835–1910)
The Three Wise Men, 1868
Oil on canvas
32¼ x 42 inches
Museum of Fine Arts, Boston
Gift of Edward W. Hooper, 1890

REGINALD MARSH (1898–1954)
"On these adventures we always went very well dressed," c. 1942
Pen and ink on paper
8½ x 11 inches
Illustration for Daniel Defoe, *The Fortunes and Misfortunes of the Famous Moll Flanders*, New York: Heritage Press, 1942
Brandywine River Museum
Museum Volunteers' Purchase Fund, 1984
84.8
See page 56

REGINALD MARSH (1898–1954)
Strokey's Bar, 1940
Watercolor
27 x 40 inches
New Britain Museum of American Art
Charles F. Smith Fund, 1941.08
See page 22

HENRY McCARTER (1864–1942)
Bells, No. 6, c. 1941
Oil on canvas
48 x 42 inches
Philadelphia Museum of Art
Bequest of Henry McCarter, 1944

HENRY McCARTER (1864–1942)
The Witch Wife, 1911
Pen and ink
21½ x 6 inches
Illustration for *Century Magazine*, April 1911
Kelly Collection of American Illustration
See page 38

WILLARD METCALF (1858–1925)
November Mosaic, 1922
Oil on canvas
26 x 29 inches
New Britain Museum of American Art
John Butler Talcott Fund, 1925.01
See page 29

WILLARD METCALF (1858–1925)
Zuni Planting Scene, 1882
Gouache on paper
13⅝ x 15½ inches
New Mexico Museum of Art, Santa Fe
Museum acquisition, 1965

THOMAS MORAN (1837–1926)
The Wilds of Lake Superior (Western Landscape), 1864
Oil on canvas
30⅛ x 45⅛ inches
New Britain Museum of American Art
Charles F. Smith Fund, 1944.04
See page 57

THOMAS MORAN (1837–1926)
View from Glenora, Stickeen River, Alaska, 1879
Carbon pencil and ink on textured paper
7¼ x 5⅞ inches
Illustration for W. H. Bell, "View from Glenora, Stickeen River, Alaska,"
Scribner's Monthly, April 1879.
Brandywine River Museum
Purchased with funds given in memory of Eloise W. Choate
and other funds, 2004
2004.6
See page 58

WILLIAM PAGE (1811–1885)
The Young Merchants, 1842
Oil on canvas
42⅛ x 36¼ inches
Pennsylvania Academy of the Fine Arts, Philadelphia
Bequest of Henry C. Carey (The Carey Collection)
1879.8.19

WILLIAM PAGE (1811–1885)
The Young Merchants, n.d.
Illustration in Seba Smith, "The Young Traders," in *The Gift*, Philadelphia,
Carey and Hart, 1844
Private collection

MAXFIELD PARRISH (1870–1966)
Dusk, 1942
Oil on masonite
13⅜ x 15⅜ inches
New Britain Museum of American Art
Charles F. Smith Fund, 1966.52
See page 16

MAXFIELD PARRISH (1870–1966)
La Palazzina (Villa Gori), Siena, 1903
Oil on stretched paper
17 x 12 inches
Museum of American Illustration at the Society of Illustrators

JOHN QUIDOR (1801–1881)
A Knickerbocker Tea Party, 1866
Oil on canvas
27 x 34 inches
New Britain Museum of American Art
Charles F. Smith Fund, 1953.06
See page 25

ELLEN EMMET RAND (1874–1941)
Dog Show, c. 1890s
Pen and ink on paper
12½ x 18 inches
Illustration for *Vogue*, c. 1890s
Ellen E. Rand
See page 59

ELLEN EMMET RAND (1874–1941)
Frederick MacMonnies, c. 1898–99
Oil on canvas
39¾ x 32¼ inches
William Benton Museum of Art at the University of Connecticut, Storrs
Gift of John A., William B., and Christopher T. E. Rand, 1967.47

ELLEN EMMET RAND (1874–1941)
Rainy Day, c. 1890s
Watercolor on paper
6½ x 3 inches
Illustration for *Vogue* or *Harper's*, c. 1890s
Ellen E. Rand
See page 60

FREDERIC REMINGTON (1861–1909)
*The Canadian Mounted Police on a
"Musical Ride" – "Charge!"* 1887
15¼ x 23½ inches
Oil on academy board
Brandywine River Museum
Museum Purchase, 1988
88.18.1
See page 61

FREDERIC REMINGTON (1861–1909)
He lay where he had been jerked, still as a log, 1893
Oil on canvas
24¼ x 36¼ inches
Gerald Peters Gallery
See page 32

FREDERIC REMINGTON (1861–1909)
They Were a Hard Looking Set, 1887
Ink on paper
10⅛ x 12¹⁵⁄₁₆ inches
Illustration for John Bigelow, "After Geronimo,"
Outing Magazine, March 1887.
Brandywine River Museum
Gift of Catherine Auchincloss, 1989
89.7
See page 62

BEN SHAHN (1898–1969)
Inside Looking Out for Seventeen Magazine, 1953
Casing on panel
17 x 15 inches
The Butler Institute of American Art, Youngstown, Ohio
Museum Purchase, 1953
See page 63

BEN SHAHN (1898–1969)
This is Nazi Brutality, 1943
Offset lithograph
40⅛ x 28¼ inches
The Museum of Modern Art, New York
Gift of the Office of War Information
107.1944
See page 65

BEN SHAHN (1898–1969)
Sketch for mural in the Social Security Building, c. 1940–42.
Tempera on paper
8¾ x 15½ inches
Collection of Rhoda and David T. Chase
See page 64

EVERETT SHINN (1876–1953)
French Vaudeville, 1937
Oil on canvas
25⅛ x 30⅛ inches
New Britain Museum of American Art
Harriett Russell Stanley Fund, 1946.22
See page 66

EVERETT SHINN (1876–1953)
Mr. Fezziwig's Ball, 1938
Watercolor on paper
4 x 7⅛ inches
Unpublished illustration for Charles Dickens, *A Christmas Carol in Prose*
(New York: Garden City Publishing Co., 1938).
Brandywine River Museum.
The Jane Collette Wilcox Collection, 1982
82.16.247
See page 67

JOHN SLOAN (1871–1951)
During the Strike, 1913
Crayon and graphite on paper
11 x 17½ inches
Delaware Art Museum
Illustration for "The Masses," September 1913
Gift of Helen Farr Sloan, 2000
(2000–621)

JOHN SLOAN (1871–1951)
Political Action, 1912
Crayon, India ink, chalk and opaque white on board
19⅝ x 13⅞ inches
Illustration for "The Masses," January 1913
Delaware Art Museum
Gift of Helen Farr Sloan, 1984
(1984–40)

JOHN SLOAN (1871–1951)
Violinist – Will Bradner, 1903
Oil on canvas
37 x 37 inches
Delaware Art Museum
Gift of Helen Farr Sloan, 1970
(1970–17)
See page 68

BEN SOLOWEY (1900–1978)
Ethel Barrymore in "The Love Duel," 1929
Charcoal on paper
32 x 16 inches
Created for *New York Times*, April 7, 1929, Theater section
Collection of the Studio of Ben Solowey

BEN SOLOWEY (1900–1978)
Rae Seated (Green Dress), 1935
Oil on canvas
45 x 36 inches
James A. Michener Art Museum
Museum purchase funded by Anne and Joseph Gardocki
See page 69

ELIHU VEDDER (1836–1923)
Illustration for cover, *Century Magazine*, February 1882
Watercolor on illustration board
8¾ x 6 inches
Courtesy of Illustration House, N.Y.

ELIHU VEDDER (1836–1923)
The Questioner of the Sphynx, 1863
Oil on canvas
36 x 41¾ inches
Museum of Fine Arts, Boston
Bequest of Mrs. Martin Brimmer, 1906

GRANT WOOD (1891–1942)
Haying, 1939
Oil on canvas on paperboard mounted on hardboard
12⅞ x 14 inches
National Gallery of Art, Washington
Gift of Mr. and Mrs. Irwin Strasburger
1982.7.1

GRANT WOOD (1891–1942)
Sentimental Ballad, 1940
Oil on masonite
24 x 50 inches
New Britain Museum of American Art
Charles F. Smith Fund, 1962.01
See page 43

N. C. WYETH (1882–1945)
At the Cards in Cluny's Cage, 1913
Oil on canvas
40 x 32
Illustration for Robert Lewis Stevenson, *Kidnapped; Being Memoirs of the Adventures of David Balfour in the Year 1751* (New York: Charles Scribner's Sons, 1913)
Brandywine River Museum
Bequest of Mrs. Russell G. Colt, 1986
86.7.5

N. C. WYETH (1882–1945)
Dying Winter, 1934
Oil on canvas
42¼ x 46⅜ unframed
47⅜ x 51⅜ framed
Brandywine River Museum
Museum purchase, 1982
82.11
See page 41

N. C. WYETH (1882–1945)
Penny Tells the Story of the Bear Fight
Movie still from Clarence Brown's *The Yearling*, MGM, 1946
8¼ x 8¼ (framed dim approx 9¼ x 9¼ inches)
Photofest Film Stills Archive
Courtesy of Photofest
See page 70

Marjorie Kinnan Rawlings, with illustrations by N.C. Wyeth, *The Yearling* (New York: Charles Scribner's Sons, 1939).
Brandywine River Museum
Illustration by N.C. Wyeth, "Penny Tells the Story of the Bear Fight".